WORLD FILM LOCATIONS SHANGHAI

Edited by John Berra and Wei Ju

First Published in the UK in 2014 by Intellect Books, The Mill, Parnall Road, Fishponds, Bristol, BS16 3JG, UK

First Published in the USA in 2013 by Intellect Books, The University of Chicago Press, 1427 E. 60th Street, Chicago, IL 60637, USA

Copyright ©2014 Intellect Ltd

Cover photo: *Lust,Caution* (2007) Focus Features

Copy Editor: Emma Rhys

Typesetting: Jo Amner

A Catalogue record for this book is available from the British Library

World Film Locations Series
ISSN: 2045-9009
eISSN: 2045-9017

World Film Locations Shanghai
ISBN: 978-1-78320-199-0
ePub ISBN: 978-1-78320-272-0
ePDF ISBN: 978-1-78320-271-3

Printed and bound by Bell & Bain Limited, Glasgow

WORLD FILM LOCATIONS
SHANGHAI

EDITOR
John Berra and Wei Ju

SERIES EDITOR & DESIGN
Gabriel Solomons

CONTRIBUTORS
John Berra
Marcelline Block
Marco Bohr
Paul Bowman
Hiu M. Chan
Chu Kiu-wai
Mariagrazia Costantino
Zachary Ingle
Wei Ju
Bjarke Liboriussen
Ma Ran
Dave McCaig
Seio Nakajima
Donna Ong
Wenfei Wang
Isabel Wolte
Xu Jia

LOCATION PHOTOGRAPHY
Jiahui Xu
(unless otherwise credited)

LOCATION MAPS
Joel Keightley

PUBLISHED BY
Intellect
The Mill, Parnall Road,
Fishponds, Bristol, BS16 3JG, UK
T: +44 (0) 117 9589910
F: +44 (0) 117 9589911
E: info@intellectbooks.com

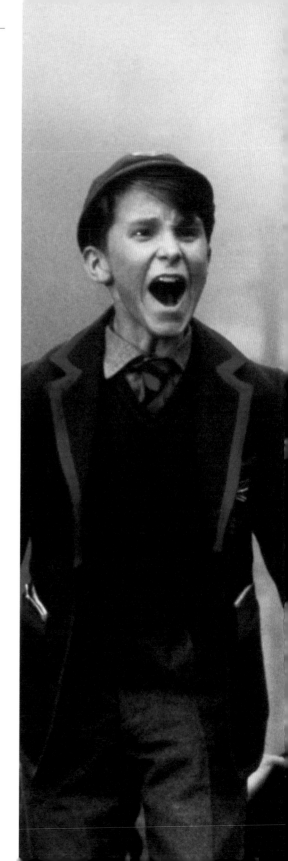

CONTENTS

Maps/Scenes

10 **Scenes 1-8**
1932 - 1947

30 **Scenes 9-16**
1984 - 2000

50 **Scenes 17-24**
2001 - 2005

70 **Scenes 25-32**
2005 - 2007

90 **Scenes 33-39**
2007 - 2010

108 **Scenes 40-46**
2011 - 2013

Essays

6 **Shanghai:**
City of the Imagination
Isabel Wolte

8 **Republican Era Shanghai:**
Hollywood of the East
Donna Ong

28 **Fists of Bruce Lee:**
Shanghai's Martial Arts
Film Legacy
Paul Bowman

48 **Lou Ye's Shanghai**
Cinema: Love and Loss in
the Urban Labyrinth
John Berra

68 **Sixth Generation Shanghai:**
Politicizing the Aesthetic
Dave McCaig

88 **Sci-fi Shanghai:**
City of the Future
John Berra

106 **The Great Divide: Depths and**
Peaks of Shanghai Life
Mariagrazia Costantino

Backpages
124 Resources
125 Contributor Bios
128 Filmography

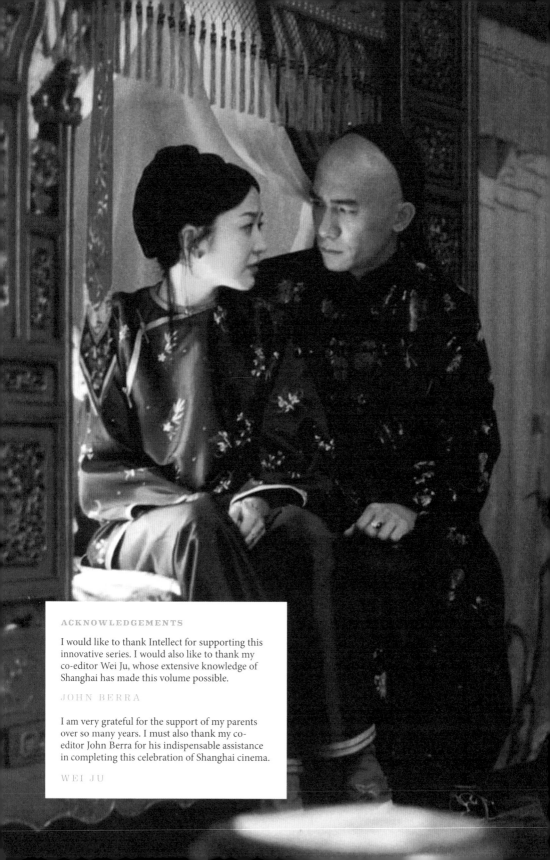

ACKNOWLEDGEMENTS

I would like to thank Intellect for supporting this innovative series. I would also like to thank my co-editor Wei Ju, whose extensive knowledge of Shanghai has made this volume possible.

JOHN BERRA

I am very grateful for the support of my parents over so many years. I must also thank my co-editor John Berra for his indispensable assistance in completing this celebration of Shanghai cinema.

WEI JU

INTRODUCTION

World Film Locations Shanghai

DUE TO SHANGHAI'S RICH CINEMATIC HISTORY, this entry in the *World Film Locations* series spans a lengthy time period from the 'Golden Age' of Chinese cinema in the 1930s to its current global position as an international production hub. As the city has recently revitalized its status as the 'Paris of the East', this volume emphasizes the glamour of such central attractions as Nanjing Road, the Oriental Pearl Tower and the luxury hotels that can be found in the vicinity of the Bund. Yet it also seeks to probe the sometimes difficult reality behind the carefully cultivated image through examination of its back streets and residential zones, while acknowledging the traditional Shanghainese culture that is still evident in its preserved *longtangs* (narrow alleys) or *shikumens* (townhouses).

To facilitate this exploration, the content of *World Film Locations: Shanghai* includes candid images captured by local film-makers, the foreign gaze of western directors and the popular lifestyle fantasies of mainland China's studio system. Shanghai has been reinvented many times during its turbulent history, and its cinematic representation has been equally susceptible to change.

It was in Shanghai that motion pictures were introduced to China with the first recorded showing of a motion picture taking place in 1896 in the entertainment quarter of Xu Garden. Initially associated with the slapstick comedic shorts that characterized the fledgling local film industry in the 1920s, the city was soon a place of social exploration for the leftist movement of the 1930s who tackled the issues of the day through such dramas as *Shennu/The Goddess* (Wu Yonggang, 1934), *Yu guang qu/Song of the Fishermen* (Cai Chusheng, 1934) and *Malu tianshi/Street Angel* (Yuan Muzhi, 1937). In the 1940s, independent producers would shoot 'blue films' and horror movies in Shanghai until the Cultural Revolution (1966–76) caused production to grind to a halt, with the exception of state-generated projects intended to raise the spirits of ordinary citizens.

When mainland China's film industry was re-established, Beijing would be the centre of activity, but Shanghai made a gradual comeback as a location. The city was featured prominently in such Fifth Generation works as *Yao a yao yao dao waipo qiao/Shanghai Triad* (Zhang Yimou, 1995) and *Feng yue/Temptress Moon* (Chen Kaige, 1996), while the Shanghai Film Park was established to provide the industry with a versatile production facility. Meanwhile, the reality of Shanghai at a time of urban revitalization would be documented by the Sixth Generation film-maker Lou Ye in his mesmerizing noir *Suzhou he/Suzhou River* (2000), setting the stage for more independent investigations of the metropolis. The gradual opening-up of China to foreign productions would culminate in its current status as a space of international cooperation, represented by such blockbusters or prestige pictures as *The White Countess* (James Ivory, 2005), *Mission: Impossible III* (J. J. Abrams, 2006), *Snow Flower and the Secret Fan* (Wayne Wang, 2011) and *Skyfall* (Sam Mendes, 2012).

The visions of Shanghai discussed in this volume range from past, to present, to future, with each reflecting the cinematic significance of a city that frequently conflates local and international identity to tantalizing effect. ✢

John Berra and Wei Ju, Editors

SHANGHAI

City of the Imagination

Text by
ISABEL
WOLTE

SHANGHAI IS AN EXOTIC CITY of glamour and luxury, with a hidden dark side. Before 1949, it was often referred to as the 'Paris of the East' or the 'Whore of the Orient', depending on the perspective. The filmic image of Shanghai is shaped by the two faces it supposedly had, either as the epitome of lustre, mystery and decadence, or as the accumulation of filth, poverty and crime. In many Shanghai films these two worlds collide. Shanghai is the only Chinese metropolis that has managed to capture the fascination of foreign and domestic film-makers alike. After the International Settlement was established in 1842, Shanghai attracted businessmen from all over the world as well as immigrants from other parts of China who came to try their luck in this emerging economic hub.

The theme of arriving in Shanghai reoccurs in many films, whether it is the early Hollywood production *The Shanghai Gesture* (Josef von Sternberg, 1941), the local *Tiyu Huanghou/ Queen of Sports* (Sun Yu, 1934) or the recent Sino-American romantic comedy *Shanghai Calling* (Daniel Hsia, 2012). Where Josef von Sternberg used studio technology to create the film noir atmosphere with sexual innuendo and suspense,

Chinese movies of the same period were filmed on location and emphasize the perils of the city. Known as the leftist film movement, these works aimed to be realistic: they followed a political mission, often concealed due to strict censorship. The tightly knit communities of the classic Shanghai street architecture with its *longtangs* (narrow alleys) assisted the underground activities of the film-makers and featured in such classic titles as *Shi zi jie tou/Crossroads* (Shen Xiling, 1937) and *Malu tianshi/Street Angel* (Yuan Muzhi, 1937).

Given its continually rising international population, Shanghai is where the Chinese film industry developed and thrived until 1949. The 'Golden Age' of Chinese cinema in the 1930s reveals a series of works in which the city is conceived as temptation; the contrast between pure country folk and corrupted city dwellers is a common feature and continues into the late 1940s in grand epics such as *Yi jiang chun shui xiang dong liu/The Spring River Flows East* (Cai Chusheng and Zheng Junli, 1947). Though generally shown through the defining buildings and structures of the concession area – the Bund, the stone lions that guard the Hongkong and Shanghai Bank, the glittering lights holding the promise of lurid nightlife – Shanghai stands for urban life in general. Initially, it fills the protagonists with awe and expectation, until they understand the falsity, injustice and the suffering of the downtrodden. Many an honest woman is forced to go into prostitution. Facing the vices active in city life, the heroes, and often heroines, will choose to join the revolution, be it against the Japanese invasion or against the abusive reign of the Kuomintang government. Despite its allure, Shanghai was a symbol of foreign oppression, a call to arms, and a place that needed to be reformed.

After the foundation of the People's Republic of China in 1949, the predominance of Shanghai as film-industry centre and location came to an

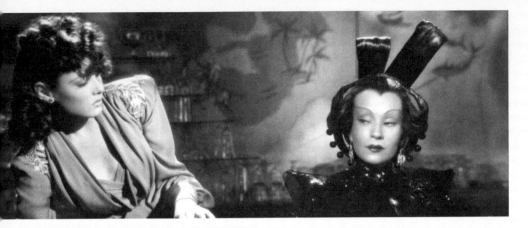

Above © 1941 Arnold Pressburger Films
Opposite © 2012 Americatown

end. The studios in the city had to deal with other subjects as defined by the government in Beijing. With *Jing wu men/Fist of Fury* (Lo Wei, 1972) and its remakes, the Shanghai of the 1920s reappears in Hong Kong cinema first as the setting for martial arts movies. It is the criminal underworld that intrigues and provides the background for the righteous to prove their strength.

The number of films made in China has been increasing steadily since the 1980s, with a staggering rise since the beginning of the twenty-first century. Despite the appeal of Shanghai as business and financial centre, there are few films that depict the modern day metropolis. The overriding image of Shanghai remains a stylized version dating back to the literary and filmic representations of the early twentieth century. The majority of movies set in this era are international productions like *Ruguo Ai./Perhaps Love* (Peter Chan, 2005) or *Se, Jie/Lust, Caution* (Ang Lee, 2007), while audiences may recognize the same corner of old Nanjing Road, as rebuilt at the Shanghai Film Park on the outskirts of the city.

Literary adaptations are numerous. Preference is given to historical pieces, one of the most internationally renowned being *Empire of the Sun* (Steven Spielberg, 1987). An exception is *Shanghai Baby* (Berengar Pfahl, 2007), based on the controversial autobiographic novel by Wei Hui, which features Shanghai's modern skyline, multi-layered highways, and the sense of confusion that infuses some of its younger inhabitants. The feeling of being lost and the search for identity is evident in independent Chinese productions like *Wo men hai pa/Shanghai Panic* (Andrew YS Cheng, 2001) or the Sino-German co-production *Suzhou he/Suzhou River* (Lou Ye, 2000). The latter is set in then-abandoned areas of Shanghai which evoke an urban situation that is mysterious and tragic. *Nanjing Lu/Street Life* (Zhao Dayong, 2006), an independent documentary, focuses on the migrants in Shanghai, a subject explored decades earlier, but this time in no way romanticized.

A few notable productions filmed in Shanghai recall major events of China's past, not focusing on the city itself but on the national calamities that took place, such as *Le violon rouge/The Red Violin* (Francois Girard, 1998) or *Meili Shanghai/Shanghai Story* (Peng Xiaolian, 2006). The semi-autobiographical *Qing hong/Shanghai Dreams* (Wang Xiaoshuai, 2005) is set in the period immediately following the Cultural Revolution with Shanghai featured only as an object of yearning and hope.

Increasingly, major Hollywood productions have chosen this modern metropolis as one of their locations. But as with the recent *Skyfall* (Sam Mendes, 2012), it seems that the 1930s Hollywood production methods have returned, with large sets being constructed in studios, thereby keeping location shooting to a minimum. In this case, again, it is a stereotype of Shanghai that is called upon, the city of exotic allure, full of unknown charms and excitement as it is created in the spectator's imagination. In most films, Shanghai continues to appear as its own cliché. ✦

The filmic image of Shanghai is shaped by the two faces it supposedly had, either as the epitome of lustre, mystery and decadence, or as the accumulation of filth, poverty and crime.

7

REPUBLICAN ERA SHANGHAI

Text by
DONNA ONG

Hollywood of the East

DURING ITS HEY-DAY as the 'Paris of the East', the major commercial and cosmopolitan city of Shanghai was the natural birthplace of the first Chinese film industry. Throughout the Republican Era from 1911–49, a recorded 3,000 films were produced, and the industry, as modelled on the Hollywood studio system, was complete with its own constellation of movie stars set against all the glitz and glamour that the city had to offer. Although very few of these films survive today, the myriad film publications that have provide an insight into the vibrant nature of Shanghai's film culture.

The city's large film audience from different sectors of society is a crucial factor in determining Shanghai as the first capital for China's film-making industry, rather than other treaty ports

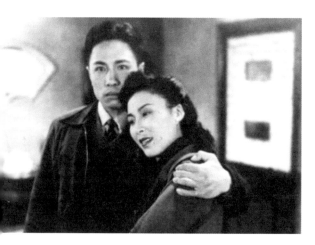

like Hong Kong. The beginnings of film viewing in Shanghai can be traced back to the first screening in 1896 by travelling showmen from the West. It became an established entertainment business after the Spaniard Antonio Ramos built the first cinema hall in 1908. Ramos's business proved extremely profitable and expanded quickly into a chain of six grand cinemas by 1920. Although early audiences were predominately foreigners living in the treaty port, it did not take long for such entertainments to catch on with local crowds. By the 1920s, going to the movies had already become an integral entertainment ritual in the city, which boasted over forty cinemas by the late 1930s.

Foreign films, primarily those from Hollywood, dominated the domestic market. Chinese audiences were enraptured by the glamour of Hollywood and its stars. Shanghai's significant educated class, ever hungry for new and cutting edge trends from the West, was a crucial driving force for foreign film imports. China was one of the largest overseas markets for Hollywood product, and during the entire Republican period, American films constituted 75 per cent of films screened in the country. High-level visits to Shanghai by Hollywood actors, by the likes of Charlie Chaplin, Mary Pickford, Douglas Fairbanks and Anna May Wong, gives some indication of the importance that the city had in relation to the American film industry.

As cinema viewing became closely intertwined with everyday life, the impact of Hollywood and western films on Shanghai culture was immense. Its influence was evident in Shanghai's fashion,

lifestyles and social values. Wealthy women were said to have taken their tailors to the cinema hall to copy dresses worn by actresses on the screen. According to *Dance World* magazine, the city's popular dance halls were also an offshoot of filmgoing culture. In the 1932 guidebook *The Gateway to Shanghai*, Wang Dingjiu recommends the cinema hall as a good place to bring one's date. Not only does it provide an intimate space in the dark, but also the fun of copying the romantic moves on-screen with one's date.

The local film industry in Shanghai was both a benefactor and victim of the foreign film presence. It was able to capitalize on the ready demand for films and learned quickly from the latest film techniques and trends of the West. Domestic films also catered to a broader Chinese population with local tastes, explaining why one of the early popular genres of the Silent era was the traditional martial arts film. At the same time, early films were important in projecting the new modern nation, often dealing with social issues facing the transitional society such as marriage, free love and the role of women. Despite the large number of films produced and strong fan followings for local movie stars, local productions were perceived to be inferior to western films and struggled to gain the same level of respectability.

The local film industry's effort to combat the monopolization of foreign films is part of a national movement to promote domestic goods against foreign imperialism. This nationalist mission to improve the fledgling industry and project a strong nation through cinema attracted the city's many intellectuals to join the film-making industry, all of whom were avid film fans. During the tumultuous years of growing Japanese aggression from 1931 to the eventual outbreak of war in 1937, film became an intense battleground with intellectuals from the left and right promoting opposing political ideologies and visions of the new nation. The leftist films that portrayed social inequality and patriotism against foreign imperialism, such as *Shennu/The Goddess* (Wu Yonggang, 1934), have come to define today's conception of Republican-era films. However, a look at the box office records show that broader entertainments, notably martial arts, romance and comedy, were also important genres of the day.

Shanghai's film industry faced and overcame the many political challenges of the early decades of the twentieth century. It survived the war years by collaborating with the Japanese occupiers, and managed to make a revival, after which some of the most sophisticated films of the period were made, the most famous now being *Xiaocheng zhi chun/Spring in a Small Town* (Fei Mu, 1948). Film production in Shanghai was eventually brought to an end when the Communist Party took power in 1949 and nationalized all mainland film-making. Many industry people found sanctuary in the British colony of Hong Kong, bringing with them film-making traditions and experience from Shanghai to help make Hong Kong the new Hollywood of the East. The most well-known Shanghai studio to impact the Hong Kong film industry from the 1950s and beyond was Shaw Brothers, formerly the Tianyi Film Company. Their entertainment films, especially period costume dramas, are one prominent legacy carried forward from their early Shanghai days.

The link between Shanghai and Hong Kong had long been established, from the pioneering period to the war years, where studios and film-makers had bases in both cities. Though few emphasize this historical link, it is important to acknowledge the first period of Shanghai cinema in setting some of the standards and establishing many of the trends or traits of today's mainstream Chinese-language films. ✦

> **Its influence was evident in Shanghai's fashion, lifestyles and social values. Wealthy women were said to have taken their tailors to the cinema hall to copy dresses worn by actresses on the screen.**

maps are only to be taken as approximates

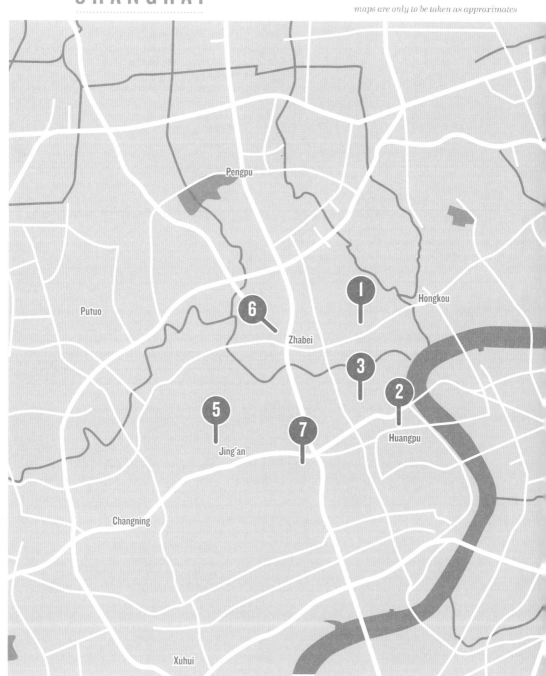

SHANGHAI LOCATIONS
SCENES 1-8

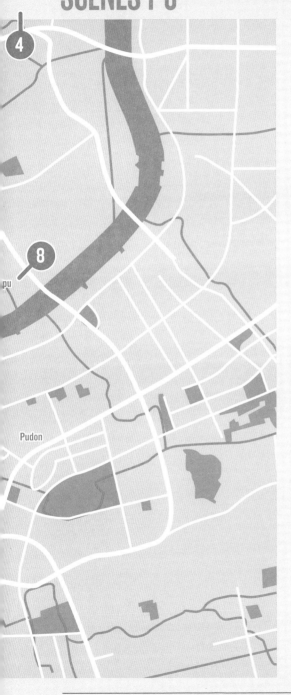

1.
SHANGHAI EXPRESS (1932)
Shanghai Railway Museum, 200 Tianmu
East Road, Zhabei District
page 12

2.
DAYBREAK (1933)
Yu Garden, 218 Anren Street,
Huangpu District
page 14

3.
THE GODDESS (1934)
Fuzhou Road, Huangpu District
page 16

4.
QUEEN OF SPORTS (1934)
Dongya Institute of Physical Education,
Fangxie Road, 388 Changhai Road,
Yangpu District
page 18

5.
SCENES OF CITY LIFE (1935)
Jing'an Park, Nanjing Road, Jing'an District
page 20

6.
CROSSROADS (1937)
Tramline, Zhabei District
page 22

7.
STREET ANGEL (1937)
Huaihai Road and surrounding area,
Huangpu District
page 24

8.
THE SPRING RIVER FLOWS EAST (1947)
Yangshupu Road, Yangpu District, near the
Huangpu River
page 26

SHANGHAI EXPRESS (1932)

LOCATION

Soundstage recreation of Shanghai North Railway Station, now ShanghaiRailway Museum, 200 Tianmu East Road, Zhabei District

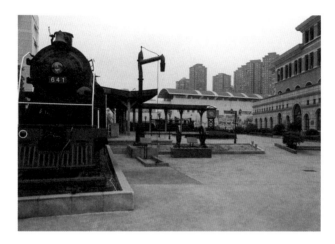

'A **DISTORTED MIRROR** of problems that beset the world today, [Shanghai] grew into a refuge for people who wished to live between the lines of laws and customs – a modern tower of Babel.' This description of the city of Shanghai by director Josef Von Sternberg is expressed vividly in his highly stylized Hollywood production *Shanghai Express*. A motley group of first-class passengers from Beijing to Shanghai during the Chinese Civil War find themselves on an expected adventure. The main characters, the notorious 'coaster' named 'Shanghai Lily' (Marlene Dietrich) and her former lover, British Captain Harvey (Clive Brook), are accompanied by a Chinese courtesan (Anna May Wong), a zealous missionary, an American gambler, a German opium dealer, a spinster boarding housekeeper, an elderly French officer and a mysterious Eurasian who turns out to be a warlord that hijacks the train. The final scene, when the train safely arrives at Shanghai station, shows the cosmopolitan 'Paris of the East' with its multiracial crowds, bilingual signs, European shops and stylish advertisements. The lively montage cuts between the media sensation caused by the train's escape from capture, the relieved passengers as they bid their farewells, and the romantic tension between Shanghai Lily and Captain Harvey who continue to resist each other until just before the very end. In classic Hollywood fashion, the two finally confess their love for each other, after Shanghai Lily buys Captain Harvey a new watch as a symbol of restored love, and the film ends with a kiss.
↝Donna Ong

Photo © Jiahui Xu

Directed by Josef Von Sternberg
Scene description: The final destination of the Shanghai Express
Timecode for scene: 1:11:36 – 1:18:10

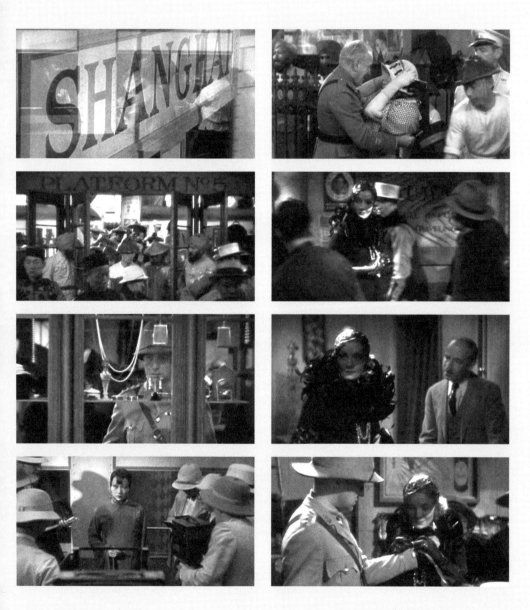

DAYBREAK/TIANMING (1933)

Yu Garden, 218 Anren Street, Huangpu District

IN THE CLASSIC silent film *Daybreak*, country girl Ling Ling (Li Lili) and her cousin Zhang (Gao Zhanfei) move to Shanghai in order to find jobs as their rural fishing village has been destroyed by warlords. There is the suggestion of romance between Ling Ling and Zhang as marriage between cousins was quite common in the old China. They both find work at a velvet factory, but soon Zhang joins the army instead and leaves Ling Ling to fend for herself in Shanghai. Ling Ling is subsequently tricked into becoming a prostitute and experiences a great deal of suffering in later life, leading to a tragic conclusion. This scene occurs just after Ling Ling and Zhang have relocated to Shanghai and decided to go sightseeing together. They arrive at the Hu Xin Ting Teahouse, which is a famous Shanghai landmark. This wooden structure was built in the Ming Dynasty and can be found in the Yu Garden, located behind the City God Temple in the Old City of Shanghai. The design of the teahouse is unique as it is in the middle of a lotus pond and the 'Z'-shaped Jiu Qu Bridge (or the Bridge of Nine Turnings) has been built around the structure. Standing on the bridge with her cousin, Ling Ling tries to feed the turtles. Turtles are known to have a long life. If you visit Hu Xin Ting Teahouse, you might be able to spot the same turtles that were featured in this film. **➼Hiu M. Chan**

Photo © John Berra

Directed by *Sun Yu*
Scene description: Sightseeing in Shanghai
Timecode for scene: 0:11:52 – 0:12:59

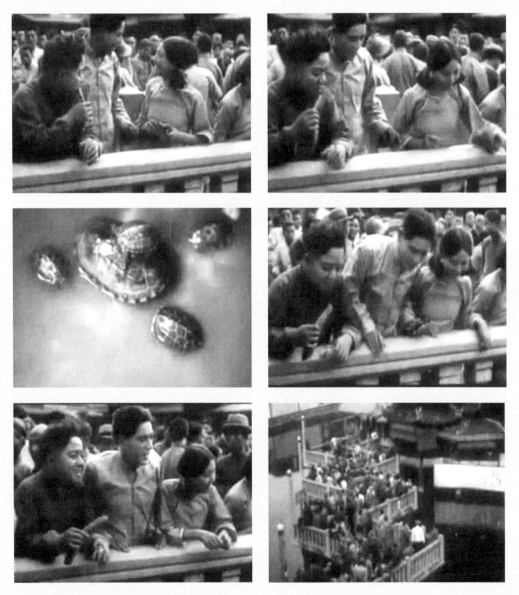

Images © 1933 Lianhua Film Company

15

THE GODDESS/SHENNU (1934)

LOCATION

Soundstage recreation of Huile Road, now Fuzhou Road, Huangpu District

THE GODDESS REFLECTS the 1930s debate, inside Shanghai's leftist intellectual circles, about the necessity to redeem exploited women, whose condition allegorically evoked that of the country then occupied by colonial empires. Besides showing a moment in the daily routine of Ruang Lingyu's anonymous character – a woman forced into prostitution in order to raise her son – and a crucial turning point in her story, this scene reproduces an aspect of the decadent atmosphere of Shanghai during the time. In particular, it presents a reconstruction of Huile Road, the heart of the red-light district that is today known as Fuzhou Road. Introduced by a shot of Shanghai skyline and the buildings near the Bund, the scene shows the 'goddess' on the street in search of clients. Just like her, the city seems to sell itself by night, where the scenography of lights is aimed at attracting people. During a sudden raid by the police, the woman looks for an escape route in a dark back alley and hides inside a lane house. She enters the room of a sleeping gambler (Zhang Zhizhi) who immediately takes advantage of the situation and forces her to stay, thereby establishing de facto his authority. In the subtle shift of Ruan's facial expression and body language, viewers can perceive the quiet resignation with which she accepts such blackmail. Apparently self-confident (this is only a performance inside the performance), she sits on a table and asks for a cigarette, directly facing the trap she has just fallen into.

↝ Mariagrazia Costantino

Photo © John Berra

Directed by Wu Yonggang
Scene description: The city gives and takes
Timecode for scene: 0:08:12 – 0:10:55

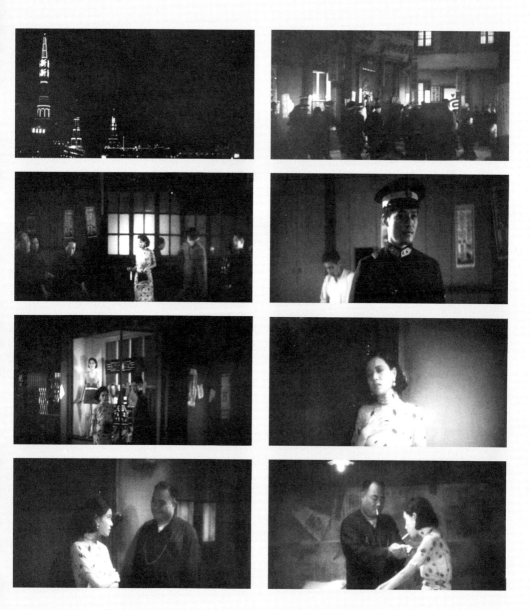

Images © 1934 Lianhua Film Company

QUEEN OF SPORTS/TIYU HUANGHOU (1934)

Recreation of the original Shanghai Dongya Institute of Physical Education, Fangxie Road, now at 388 Changhai Road, Yangpu District

QUEEN OF SPORTS is a silent film about Ying Lin (Li Lili), a young girl from a wealthy family who establishes her career in athletics. She grows up in the countryside and begins to attend sports school after she moves back to Shanghai. During her training, Ying Lin falls in love with her coach. Later, she wins several medals at different competitions and is anointed the title of 'Queen of Sports'. The film celebrates the image of the new independent Chinese woman. During the Republic of China (1912–49), people would return from studying overseas with a passion for modernizing the country. Some of them believed that physical training for youngsters was a way to strengthen the country leading to physical education being established. Although the sports college in the film is called Jinghua, it references a private institution called Dongya – an institute for physical education that was founded in 1918. The official English name of the institution is long lost, and the modern version of it is a government college instead of a private one. In this scene, Ying Lin is taken to Jinghua Sports College for her first day. Her father meets with the headmaster and introduces his daughter. After the meeting, Ying Lin meets a friend that she grew up with, and is subsequently introduced to her friend's brother, Yunpeng, who works as a coach at the school. Ying Lin and Yunpeng fall in love with each other at first sight. **➻ Hiu M. Chan**

Photo © Jiahui Xu

Directed by Sun Yu
Scene description: Love at first sight
Timecode for scene: 0:15:44 – 0:18:16

Images © 1934 Lianhua Film Company

SCENES OF CITY LIFE/ DUSHI FENGUANG (1935)

Jing'an Park, Jing'an District

THE IMAGES OF SHANGHAI in *Scenes of City Life* evoke the dream of a family moving from the countryside moving to the big city. Shanghai becomes a spectacle and a synthesis of lights, with signs in English and Chinese, while billboards advertise new forms of entertainment, including cinema itself. This paradigmatic scene, also used by director Yuan Muzhi in his later *Malu tianshi/Street Angel* (1937), begins with the bi-dimensional image of an urban landscape of cardboard and bulbs, peeped at through the hole of a magic lantern that becomes 'real', yet not less prototypical. The shift to the real Shanghai and its images is also signalled by the score's precipitating crescendo. From day to night, the city spectators (the four family members, moviegoers and the audience) witness the blooming of a sophisticated urban culture in its heyday. Viewers can see themselves in the elegant couples idly strolling through Jing'an Park, a very fashionable spot for foreigners and modern youth at that time, or dream about being those people. The most famous buildings, seat of big companies such as Air Mail or Postal Savings are shown with a superimposition of falling golden coins. Everything seems to be blessed by wealth in Shanghai and everything is strictly ruled by time, as the images of clocks seem to suggest. These shots convey a feeling of ascension, while the restless rhythm of the night pulsates in the frantic dances of the parties and the presence of their foreign faces. As the dream goes on, the city streets at once confirm and deny this vision.

➻ Mariagrazia Costantino

Photo © Jiahui Xu

Directed by Yuan Muzhi
Scene description: City Lights
Timecode for scene: 0:03:37 – 0:06:25

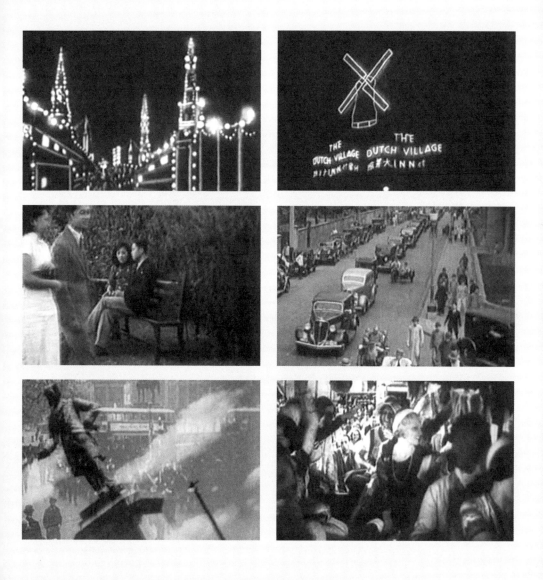

CROSSROADS/SHI ZI JIE TOU (1937)

Zhabei District

IN THIS ROMANTIC DRAMA by the legendary leftist film-maker Shen Xiling, two struggling youths come to one another's attention while commuting daily on a crowded tram. In this scene, the two finally have their first encounter when Zhao (Zhao Dan) helps Yang (Bai Yang) to retrieve a letter that she has dropped out of the window. They continue to steal glances at each other as the tram pulls into the next stop, which is located in Zhabei, one of Shanghai's then Chinese-administered districts. Little do they know that, not only do they share the same dingy subdivided apartment in a cramped *longtang* neighbourhood, separated only by a flimsy wooden wall, but they have already engaged in several rounds of nasty pranks. Although the two practically live and sleep side by side, it is ironic that they should only meet in a public space like the tram. As it so happens, Yang works a dayshift as a factory trainer, while Zhao works a nightshift as a newspaperman. Despite the uncanny forces of fate that keep pulling the two together, they both happen to lose their jobs at the end of the film, which forces them to struggle for both survival and love. As part of the leftist wave of the 1930s, *Crossroads* exposes the harsh realities of how Chinese youth must suffer the ordeals of a modern Shanghai that is far from the glamour of the foreign concessions, and on the brink of an all-out war with Japan. **⚫Donna Ong**

Photo © Jiahui Xu

Directed by Shen Xiling
Scene description: *Young workers find love on a crowded tram*
Timecode for scene: *0:56:42 – 0:58:22*

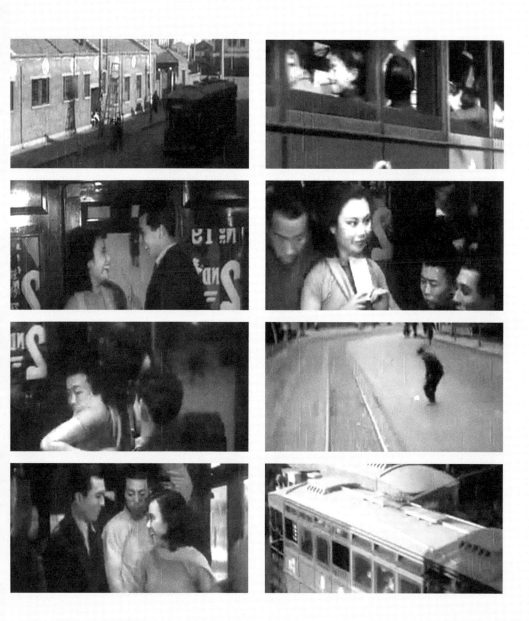

STREET ANGEL/MALU TIANSHI (1937)

LOCATION

*Ba Xian Qiao, now Huaihai Road
and surrounding area, Huangpu District*

CHARMING, humorous and filled with subtle irony, *Street Angel* is a gem amongst the left-wing Chinese films of the 1930s. While concentrating on the relationship of a young couple and their friends, the struggles of the lower classes are shown in a predominantly light-hearted manner. During the opening credits, the flash and glamour of Shanghai, with its bustling streets and symbols of foreign power, act as backdrop, before director Yuan Muzhi refines his focus to the lower depths of society. The whole story takes place in a part of Shanghai formerly called Ba Xian Qiao. In the early decades of the 1900s, this was a busy area surrounding an open market with shops and small restaurants aligning the narrow alleys. In this scene, male lead Xiao Chen (Zhao Dan) summons his friends with a bugle call. They pass street characters while marching home through the Gate of Peace. In a later scene, the Chinese characters on the gateway will be varnished, referring to a traditional saying, literally 'Whitewashing Peace', with the figurative meaning of giving a false appearance of peace and prosperity. It was only in this way that the film-makers could express anger at the ongoing Japanese invasion while avoiding censorship. Other jabs at the then-government can be found in the lyrics of the ever-popular songs of lead actress Zhou Xuan and other filmic details. Today, high-rise structures stand here on the corner of Xizang Nan Road and Yanan Dong Road. **◆Isabel Wolte**

Photo © Jiahui Xu

Directed by Yuan Muzhi
Scene description: Going Home
Timecode for scene: 0:12:12 – 0:13:12

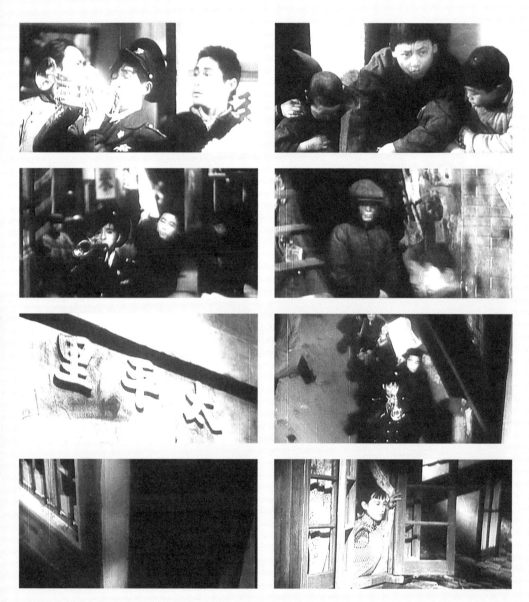

Images © 1937 Mingxing Film Company/Star Film

THE SPRING RIVER FLOWS EAST/
YI JIANG CHUN SHUI XIANG DONG LIU (1947)

LOCATION *Yangshupu Road, Yangpu District, near the Huangpu River*

SET IN WAR-TORN 1930s Shanghai, this melodrama offers a microcosm of what people went through during those tragic times. The peaceful Huangpu River is witness to a heartbroken Sufen (Bai Yang), as followed by her tearful child Kangsheng, as they rush towards a wharf. The reunion with her long-lost husband, Zhang Zhongliang (Tao Jin), emotionally shatters Sufen; a faithful wife, caring mother and filial daughter-in-law. She cannot accept that her beloved Zhongliang has already turned into a social climber and has been living in affluence with another woman, Wang Lizhen (Shu Xiuwen), while she has struggled to put food on the family table. Hopeless and helpless, Sufen decides to give up her life, and sends Kangsheng away to buy her some food. She writes her will on the back of the wedding photo that she has been keeping. It tells her son to follow in the footsteps of his virtuous uncle instead of falling into the traps of vanity and lust, like his father. Sufen jumps into the rapid Huangpu River before her son returns with two pan-fried rice cakes. Everyone involved gathers by the river. The guilty Zhongliang is reduced to tears by the news and his mother's pent-up reprimand, once she arrives on the scene. Yet the enraged Lizhen sneers at this tragedy. She goes so far as to urge her cousin to honk the horn in order to have Zhongliang get back in the car. His mother questions the one above whilst the speechless river flows on.
➻ **Xu Jia**

Photo © Jiahui Xu

Directed by Cai Chusheng and Zheng Junli
Scene description: Tragedy at the Huangpu River
Timecode for scene: 3:04:16 – 3:11:23

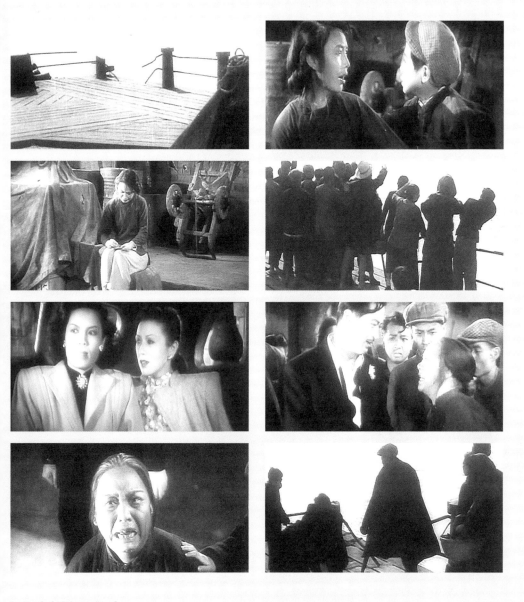

FISTS OF BRUCE LEE

Shanghai's Martial Arts Film Legacy

Text by PAUL BOWMAN

SHANGHAI CAME UNDER the control of Britain in 1842. It grew into a metropolis in this context: not simply Chinese, and also an internationally significant link in international trade and power networks. Consequently, even today, it is not uncommon for cultural snobs elsewhere in China to regard the cultures of cities like Shanghai and Hong Kong as being 'inferior', 'corrupted' or 'contaminated' by non-Chinese influences. Control of Shanghai was contested, managed and manipulated by western interests throughout the nineteenth century. It saw settlements and administrative areas conceded to British, French and American powers. However, what registers and resounds most powerfully in terms of Chinese cultural memory about Shanghai relates to events of the mid-twentieth century – namely, the Japanese occupation of Shanghai throughout World War II. It is doubtless because the trauma and painfulness of that period of occupation was still raw in the early 1970s that one of the most globally significant Hong Kong martial arts films was set in Shanghai and takes the Japanese as the enemy. This is the international blockbuster *Jing wu men/Fist of Fury* (Lo Wei, 1972).

The film stars Bruce Lee. It is set circa 1910 and tells a story in which a Chinese martial arts school (Jing Wu) in the Shanghai International Settlement is victimized by the Japanese powers. The founder of the school, Huo Yuanjia, has died in mysterious circumstances. Bruce Lee plays Chen Zhen, a student of Huo who uncovers that his master was poisoned by a rival Japanese school. Chen Zhen then goes on to have murderous revenge, before being gunned down.

Fist of Fury had a global impact because it is steeped in Chinese cultural nationalism and because of Lee's groundbreaking fight choreography, which remains astonishing. Without Lee's choreography, the film would not have been such a success; but it is in terms of the film's Chinese cultural nationalism that Shanghai plays a crucial role.

Shot predominantly indoors in Hong Kong, *Fist of Fury* only incorporates 'Shanghai' in two ways: in terms of references to the size of the city, and to it being controlled by the Japanese. This resounded with Chinese audiences, who immediately read *Fist of Fury* as being 'about' China. The suppression of the Jing Wu School in Shanghai stands for China's suppression by foreign powers. In other words, in this film, Shanghai 'is' China. Moreover, the entire history of the colonization and suppression of China by foreign powers is condensed into its most recent occupation by Japan in the early twentieth century.

This involvement of Shanghai in processes of filmic condensation and displacement returned in interesting ways in Hong Kong and Chinese cinema in the wake of the handover of Hong Kong from British to Chinese control in 1997. As a city with even more of a dual status than Shanghai, the relationship between the Communist

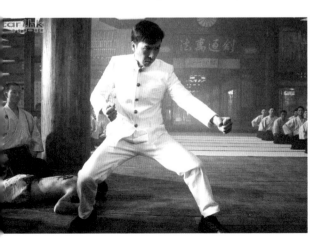

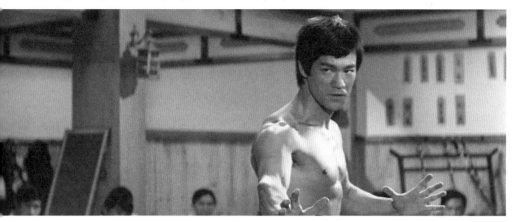

mainland PRC and the thoroughly westernized and extremely wealthy capitalist Hong Kong had to be renegotiated in this process, on lots of levels and in lots of ways. One of these was cultural. And the question was this: what is the cultural relationship between Hong Kong and China? Cinema provided some answers, or responses, and Shanghai often had an important role to play in them.

This can be seen in the proliferation of films post-1997, which are clearly organized by Hong Kong's most famous 'Chinese export', Bruce Lee. Lee has a kind of spectral and structuring presence in the films, even if they are not literally about him. Most prominent has been the series of films about Bruce Lee's *wing chun* ("spring chant") kung fu instructor, Ip Man. These started out as action films with *Yip Man/Ip Man* (Wilson Yip, 2008) and *Yip Man 2/Ip Man 2: Legend of the Grandmaster* (Wilson Yip, 2010). But by 2013, the canon of Ip Man films came to include *The Grandmaster* (Wong Kar-wai, 2013), which was more of an aesthetic art object. But what all these films have in common is the fact that they all mythologize Ip Man. Moreover, they often represent him as a Chinese nationalist hero, who fought against the Japanese and who was ultimately forced to flee mainland China and relocate in Hong Kong. In this way, Hong Kong is rewritten as being a place that includes Chinese nationalists who moved from the mainland to escape not the Communists but the Japanese.

This is an affective jumble, of course. The facts of history are almost entirely obfuscated to the point of irrelevance. And it is into this affective nationalist soup that Shanghai returns. In one of the films from the loose series or cycles of films that are, in one respect or another, 'about' Bruce Lee (albeit always in condensation and displacement), the character that Bruce Lee made famous in *Fist of Fury*, Chen Zhen, returns to Shanghai. Lee's anti-Japanese nationalist Zhen was killed at the end of the film. However, *Jing wu feng yun: Chen Zhen/Legend of the Fist: The Return of Chen Zhen* (Andrew Lau, 2010) proposes that he was not actually killed in Shanghai, but escaped, to fight against the Germans in the trenches of Europe in World War I. He returns to Shanghai under an assumed identity but soon ends up fighting against the plotting of the Japanese. Interestingly, in this film, Chen Zhen is conflated not only with Bruce Lee, but also with Jet Li in *Jing wu ying xiong/Fist of Legend* (Yuen Woo-ping and Gordon Chan, 1994), and – bizarrely – also with the character 'Kato' that Bruce Lee played in the American television series *The Green Hornet* (George W. Trendle and Fran Striker, ABC, 1966–67).

A great deal is mixed into these filmic cocktails, but whenever Shanghai appears, it is always playing a role. Shanghai is never simply a location. It is never simply any old place. In the thematic threads stretching back at least to Bruce Lee in 1972, Shanghai is very often cast as China itself – but China in jeopardy. As China, Shanghai is very often weak, facing great threats, or subjugated under foreign control; but it is also always something worth fighting for. ✢

Fist of Fury had a global impact because it is steeped in Chinese cultural nationalism and because of Lee's groundbreaking fight choreography, which remains astonishing.

LOCATIONS MAP

SHANGHAI

maps are only to be taken as approximates

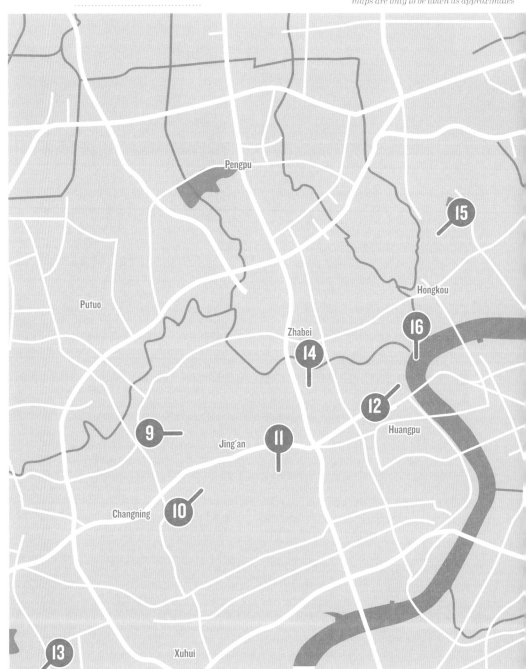

SHANGHAI LOCATIONS
SCENES 9-16

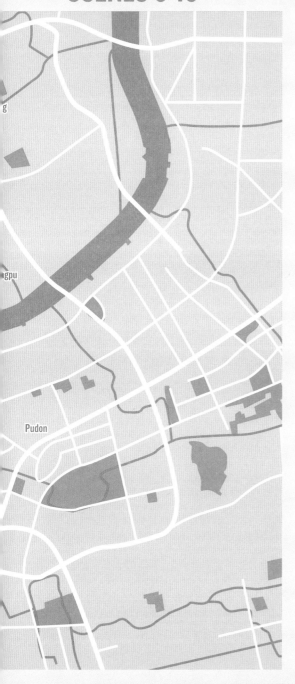

9.

INDIANA JONES AND THE TEMPLE
OF DOOM (1984)
The Paramount, 218 Yuyuan Road,
Jing'an District
page 32

10.

EMPIRE OF THE SUN (1987)
Panyu Road, Changning District, Zhongshan
East Road, Huangpu District, the Bund
page 34

11.

CENTER STAGE (1992)
Studio No.1, The Lianhua Film Company,
2006 Huaihai Zhong Road
page 36

12.

SHANGHAI TRIAD (1995)
The Docks at The Bund, Zhongshan road,
Huangpu District
page 38

13.

TEMPTRESS MOON (1996)
Shanghai Film Park, 4915, Bei Song
Highway, Chedun, Songjiang District
page 40

14.

FLOWERS OF SHANGHAI (1998)
Nanjing Road, Huangpu, District
page 42

15.

THE RED VIOLIN (1998)
Hong Zhen Old Street, Hongkou District
page 44

16.

SUZHOU RIVER (2000)
Suzhou River, Huangpu District
page 46

INDIANA JONES AND THE TEMPLE OF DOOM (1984)

LOCATION *Soundstage recreation of a 1930s Shanghai nightclub*

THIS SECOND INSTALMENT in the Indiana Jones series opens with a visual gag involving the logo of Paramount Pictures. The famous studio logo fades into a metallic mountain, and as the camera zooms out, we learn that this mountain adorns an enormous gong, struck by a scantily clad Asian muscleman. Influenced by the menacing orchestral music, viewers will perhaps think of the Asian villain stereotypes that were so popular in the pulp fiction of the 1930s, the era in which the first three Indiana Jones movies are set. But it is quickly revealed that the muscleman is merely part of a harmless Shanghai nightclub show and the gong strokes do not signal the arrival of Fu Manchu or Ming the Merciless. Instead, they call attention to singer Willie Scott (Kate Capshaw), emerging from the mouth of a dragon. Kate sings the title song from Cole Porter's musical *Anything Goes* (which premiered in 1934, the year before this series instalment takes place) in (mock) Mandarin. She runs back inside the dragon, into an extra-diegetic space where a heightened, more lavish version of the dance routine plays out. Kate then re-emerges carrying a large, red banner which briefly covers the entire frame before it falls away to reveal a sinister part of the audience: a group of Shanghainese gangsters. Unlike the gong-playing muscleman, these spectators turn out to be the real villains. The scene is now set for a self-referential adventure yarn in which nothing is what it seems.

➶**Bjarke Liboriussen**

Photo © Jiahui Xu

Directed by Steven Spielberg
Scene description: Opening song and dance routine
Timecode for scene: 0:00:00 – 0:02:51

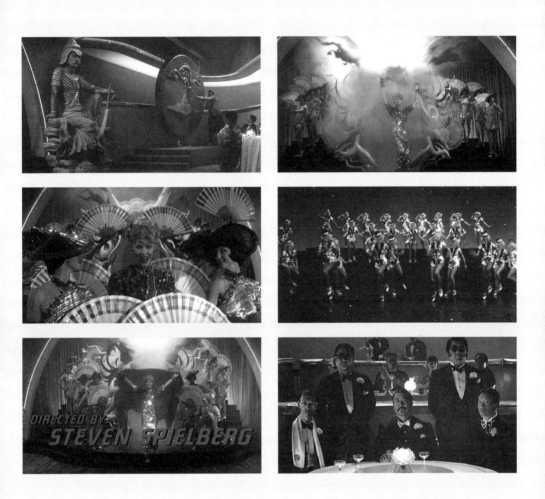

Images © 1984 Paramount Pictures

EMPIRE OF THE SUN (1987)

LOCATION

Panyu Road, Changning District, Zhongshan East Road, Huangpu District, the Bund

BASED ON J. G. BALLARD'S 1984 novel, *Empire of the Sun* follows the development of British schoolboy Jim (Christian Bale), who is left alone following traumatic separation from his parents, and the parallel spoliation of Shanghai at the end of its golden years. In this scene, Jim's upper-class British family leave their house on the central Panyu Road to attend the masked Christmas ball at the residence of the British Ambassador. As they sit in a black, chauffeur-driven Rolls Royce, Jim's father instructs the driver to take Huangpu Road (now Zhongshan East Road) to avoid the crowd. A birds-eye view of the streets on the eve of the Japanese occupation shows a congested city. Jim, disguised as the sultan Simba, stares from the car window at the chaotic movement of the city, as if he were watching a movie. The people on the streets – market sellers, peasants, foreign soldiers, Chinese girls and a nun – are seen from the mesmerized perspective of the boy, who is alarmed and excited by the incessant movement of the city. But as the car leaves the city centre and – in a form of allegorical turning point – two dead chickens hit the vehicle's window staining it with blood, the situation seems to fall apart. Thousands of refugees from the countryside invade the streets and try to force the police blocks. At the same time, the wealthy families head to the ball, completely cut off from a place idealized in the turmoil of a crucial historical phase. ➻**Mariagrazia Costantino**

Photo © Jiahui Xu

Directed by Steven Spielberg
Scene description: Wartime Shanghai seen from a Rolls Royce
Timecode for scene: 0:09:29 – 0:13:19

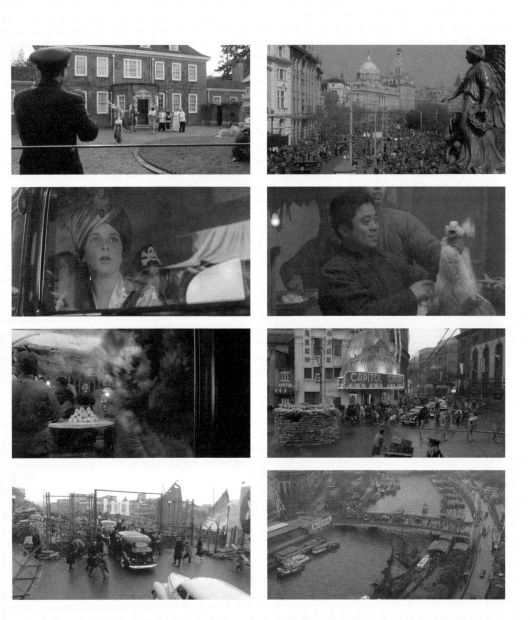

CENTER STAGE/RUAN LINGYU (1992)

LOCATION *Recreation of Studio No. 1, Lianhua Film Company, 2006 Huaihai Middle Road*

CHINESE CINEMA originated in Shanghai, with many contributions from the Lianhua Film Company in the 1930s. *Center Stage* tells the story of star actress, Ruan Lingyu (Maggie Cheung) and the development of Shanghai cinema. In 1932, soon after the January 28 Incident, Ruan returned to Shanghai and rejoined Lianhua. At its peak, the company owned several huge production studios, including Studio No.1 in Huaihai Zhong Lu which saw the production of many classics, such as *Ye cao xian hua/Wild Flowers* (Sun Yu, 1930) and *Lian ai yu yiwu/Love and Duty* (Bu Wancang, 1931). Through its account of the events that took place at Studio No. 1, *Center Stage* reconstructs the golden era of the film company. When the Japanese invasion of China broke out, progressive socialist personnel in the film circle assembled at Lianhua to share their concerns about the country's political development. Through production of revolutionary films and music, they called upon all Chinese people to rise and unite against the enemy. Lianhua's Studio No. 1 ceased operations in the late 1930s as a result of the Japanese invasion, but its buildings were not completely dismantled until the early 1990s. Towards the end of *Center Stage*, the shot of a reconstructed Studio No. 1 is followed by footage of the actual site of the production facility in the 1990s. Shown in black and white, the site has changed beyond recognition. From a revolutionary powerhouse in its glory days, it has sadly become a site of dilapidated ruins and debris. ⇔*Chu Kiu-wai*

Photo © Jiahui Xu

Directed by Stanley Kwan
Scene description: Revisiting the Golden Age of the Lianhua Film Company
Timecode for scene: 0:45:29 – 0:49:57

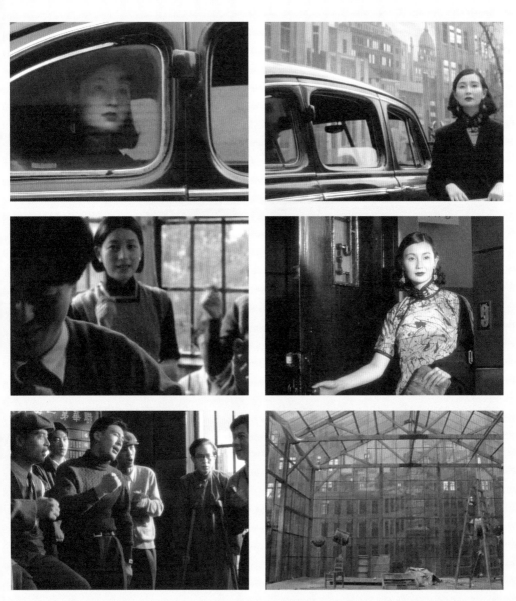

SHANGHAI TRIAD/
YAO A YAO YAO DAO WAIPO QIAO (1995)

LOCATION *The Docks at the Bund, Zhongshan East 1st Road, Huangpu District*

ZHANG YIMOU'S compelling crime saga of one boy's lost innocence amidst the corruption that constitutes the Shanghai underworld of the 1930s is seen through the wide-eyed wonder of young villager Shuisheng (Wang Xiaoxiao). At the time, Shanghai was the most western of Asian cities and, from the outset here, is presented as bewitching for the boy who arrives from a region that has yet to experience the turbulence of social-economic development. As he apprehensively waits for his ride to the house of the triad boss, Zhang frames Shuisheng's face in close-up to accentuate his first impression of the hustle and bustle of the busy docks. Zhang intersperses the reactions of the boy with a wide shot that takes in a view of the Huangpu River and the surrounding Bund. With grand international architectural influences as a consequence of colonial prominence, such as Baroque and Romanesque, many of the differing styles of towering constructions within this scene would have been present on the waterfront in the 1930s when they housed commercial, financial and political institutions. Today, these landmarks remain externally as they were on construction in the 1920s thanks to recent restoration projects, now sitting side by side with newly erected restaurants, shops and art galleries. Steeped in history and at its most beautiful at night, visitors walking through the waterfront district may end up replicating the wide-eyed wonder of Shuisheng as they take in the sights and sounds of one of the most famous parts of Shanghai. •»*Dave McCaig*

Photo © Jiahui Xu

Directed by Zhang Yimou
Scene description: Village boy Shuisheng arrives in Shanghai
Timecode for scene: 0:00:55 – 0:02:36

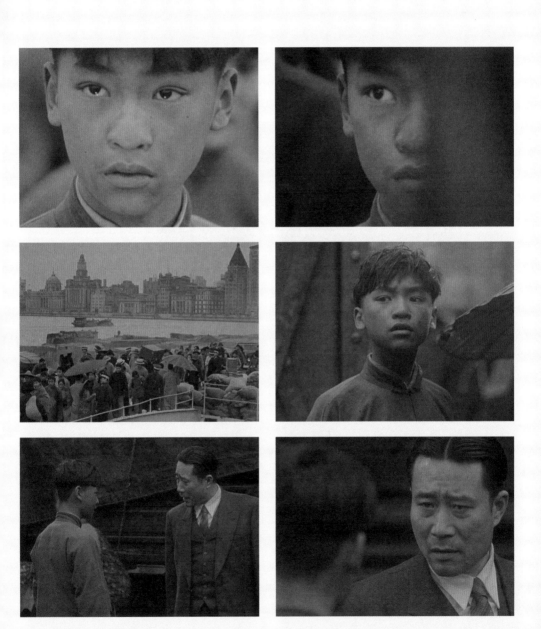

Images © 1995 Shanghai Film Studios

TEMPTRESS MOON/FENG YUE (1996)

LOCATION

Shanghai Film Park, 4915, Bei Song Highway, Chedun, Songjiang District

THE MODERNIZED CITY of Shanghai is contrasted with the countryside of Jiangnan in *Temptress Moon* through the rural origins of the principal characters. In one of the Shanghai strands, Tianxiangli (Heavenly Lane) serves as a location for Zhongliang (Leslie Cheung) to ply his trade of seducing wealthy, married women. After one falls for him, his fellow triad members break in during one of their tête-à-têtes, blindfold her, falsely tell her that her lover is dead and instigate a blackmail scheme. In this, Zhongliang's second trip to Tianxiangli, he has an early morning rendezvous with Mrs Shen (Jie Zhou), whom he had met in an earlier scene at the same locale. Meanwhile, Ruyi (Gong Li), the ruler of the Pang clan who has developed a romantic longing for Zhongliang during his time at their estate, is forced by gang members to view the tryst from a building across the street. Feeling betrayed, Mrs Shen refuses to succumb to blackmail and commits suicide by jumping off the balcony. Also shocked by Zhongliang's duplicity, Ruyi covers Mrs Shen's face, while a crane shot reveals Tianxiangli above the gate. Flush with Christopher Doyle's typically oneiric cinematography, this scene also benefits from Chen's use of parallelism (earrings, curtains) in the editing between the activities taking place in the two buildings. *Temptress Moon* is the film that initiated the prominence of Shanghai Film Park, located in the suburban Songjiang district, as a base for productions that recreated early-twentieth-century China. **↝Zachary Ingle**

Photo © Jiahui Xu

Directed by Chen Kaige
Scene description: Suicide at Tianxiangli
Timecode for scene: 1:31:21 – 1:38:57

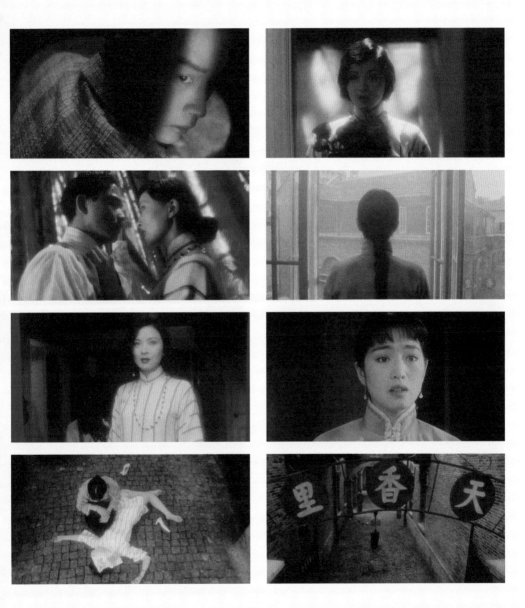

FLOWERS OF SHANGHAI/HAI SHANG HUA (1998)

LOCATION *Soundstage recreation of a nineteenth-century flower house in the British Concession, now Nanjing Road, Huangpu District*

A FLOWER HOUSE should be a joyful haven for men who are trapped in arranged marriages or otherwise unable to meet female entertainers, but the establishment depicted in *Flowers of Shanghai* seems cloudy and claustrophobic. A subtle sense of ownership stifles the relationship between courtesan Crimson (Michiko Hada) and wealthy patron Wang (Tony Leung): she wants to possess and be possessed by Wong due to an eagerness to pay off her debt as well as the affection that has been built up over the years. Wong's interest wanes and he drinks with Jasmine (Vicky Wei), a much younger courtesan. Crimson feels insulted, but it's mostly jealousy. Worse still, it worries her that Wong might never clear her debts as promised as he is now squandering money on Jasmine. Wong's friends come to help him muster the courage to face the frustrated Crimson. The courtesan's madam lavishly describes her lady's sorrow and embarrassment, criticizing Wong's unannounced 'betrayal'. After his friends have departed, Wong apologizes and assures Crimson that he will keep his promise. However, the weeping girl is not convinced until Wong goes to hold her and speaks in their shared dialect of Cantonese and the scene ends with the two embracing. The dimly lit room is by no means a space of tender care and love, but one full of bitter accusation, obsessive complaints and demanding requests, as enhanced by the indulgences of opium, tea and wine. Even the exquisite furniture appears to be a silent accomplice in this male-dominated structure. **Xu Jia**

Photo © Jiahui Xu

Directed by Hou Hsiao-hsien
Scene description: Crimson launches an emotional war on the 'unfaithful' Wong
Timecode for scene: 0:09:00 – 0:17:40

THE RED VIOLIN/LE VIOLON ROUGE (1998)

Hong Zhen Old Street, Hongkou District

THE RED VIOLIN episodically retraces the journey of the titular musical instrument from its seventeenth-century origins in the workshop of fictional Italian violin maker Nicolò Bussotti to late-twentieth-century Montreal. Throughout three centuries, this legendary violin crosses cities, countries and continents, exchanging hands from owner to owner. In the Shanghai segment, the film explores the impact of the Cultural Revolution upon this instrument's travels. During a Communist rally, after witnessing the mass burning of objects considered to be relics of capitalist exploitation and 'degenerate Western art', party official Xiang Pei (Sylvia Chang) surreptitiously saves the red violin – a gift from her professional violinist mother – by giving it to music teacher Chou Yuan (Liu Zifeng), who was ordered to destroy his own violin in the fire. He shelters the red violin in his attic. After his death in the present day, his lifeless body is discovered, surrounded by a cache of musical instruments. Chou Yuan's low-rise house – part of a row of similar homes – remains unchanged, yet is adjacent to rising skyscrapers, and is thus situated at the threshold where the old intersects with, and will be overtaken by, the new. This construction boom is emblematic of changes not only in the cityscape but also in politics. Now, rather than destroying such instruments, the government sends them to an elite auction house. This scene encapsulates the film's preoccupation with death and destruction as well as rebuilding and rebirth. From Montreal, the red violin will move on to its next destination and owner. **➻Marcelline Block**

Photo © Jiahui Xu

Directed by François Girard
Scene description: 'I will keep it safe.'
Timecode for scene: 1:32:13 – 1:34:13

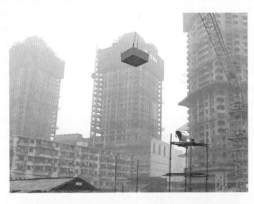

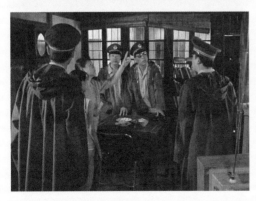
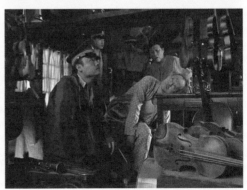

Images © 1998 Rhombus Media

SUZHOU RIVER/SUZHOU HE (2000)

Suzhou River, Huangpu District

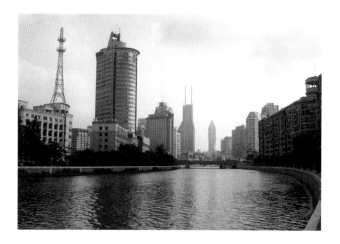

SUZHOU RIVER is a caprice creek that flows into the Huangpu River at the northern end of the Bund in Huangpu district and is intrinsically linked with the history of the city due to its role as an international trade port. The story of *Suzhou River* begins with the monologue of an unseen videographer as his camera focuses on the nearby landscape and the water itself, with the murky depths symbolizing the dark secrets of the city. The bank is comprised of filthy dwellings, deserted factories, shabby boats and old bridges. People of low economic status reside and work on this waterway, with this opening sequence establishing the film's desperate emotional tone. By applying the documentary style of handheld photography and jump-cuts, the sequence captures the sense of motion that is a characteristic of the modern city, with passers-by often looking directly into the videographer's lens. These fractured images are grey and melancholy, reflecting the area's serious pollution level. This hygiene problem was in the process of being solved at the time of the film's production due to an urban regeneration project that was launched with the intention of cleaning up the river and its dilapidated surroundings. As a result, this ruined district was eventually revitalized by new buildings and roads, with the grim poverty on display here, no longer to be seen. *Suzhou River* witnesses the development of Shanghai, recording a memory of the city that, in turn, evokes the tumultuous history of its past one hundred years.

⊷ Wenfei Wang

Directed by Lou Ye
Scene description: *Recording the redevelopment of Suzhou Creek*
Timecode for scene: *0:00:40 – 0:04:20*

LOU YE'S
SHANGHAI CINEMA

Text by
JOHN
BERRA

Love and Loss in the Urban Labyrinth

BORN IN SHANGHAI in 1965, Lou Ye rose to international prominence as a member of the loosely-grouped Sixth Generation of Chinese film-makers which also includes Ning Ying, Wang Xiaoshuai and Zhang Yuan. Lou shares with his contemporaries an interest in the city as much of his work focuses on those unfortunate inhabitants who have been left on the social-economic fringes during China's unstoppable rise to superpower status. However, within the context of this film-making group, Lou's sustained focus on Shanghai is relatively unique, as is the manner in which he frames the city as a space of chance encounters and sexual desire, embracing its romantic potential even when exploring its seedy underbelly. Lou's preference for tight framing, multiple edits and jump-cuts often makes it difficult to identify specific locations, but his dizzying aesthetic brilliantly conveys the metropolis in a state of perpetual motion.

Shanghai is a site of youthful dissatisfaction in Lou's debut feature, *Zhou mo qing ren/Weekend Lover* (1995), with true love being threatened

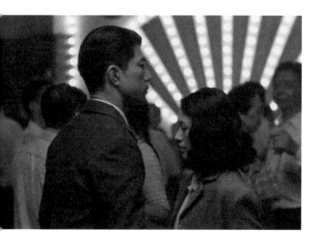

by the destructive urges that stem from social marginalization. *Weekend Lover* concerns the love triangle that develops between ex-convict A Xi (Jia Hongshen), his former girlfriend Li Xin (Ma Xiaoqing) and her new boyfriend La La (Wang Zhiwen). The film introduces many of the key elements that would permeate the director's later work: existential characters, sudden bursts of violence and a pervading sense of urban alienation. Lou plays with noir tropes as the principal players inhabit squalid spaces that await regeneration, while Li Xin's relative upward mobility due to her position with a shady company is shattered overnight when the business is wiped out. The camera follows A Xi down back alleys and dimly lit corridors as he stalks Li Xin in the hope of reconciliation, although her affections have shifted to La La, a sensitive musician. La La's band can only rehearse in abandoned spaces due to the strict restrictions on art-related activities and the success they achieve from an underground gig is short-lived due to La La's collision course with the volatile A Xi.

The city is reconfigured as a space of gothic terror in *Wei qing shao nu/Don't Be Young* (1995), an unsettling horror story in which troubled young woman Lan (Qu Ying) is not only haunted by her mother's suicide from years earlier, but has started to experience vivid nightmares that she is increasingly unable to distinguish from reality. Enlisting the help of her concerned friend Lu Mang (You Yong), she tries to unravel the mysteries of her subconscious, the main clue to which seems to be the recurring address of 1999 Huosangerlu, although the street is not found on any map of Shanghai. An opening title card states that the film is set in 'another time, another place', with Lou avoiding signs of modernity to maintain a disorientating balance between the real and the imagined. The crumbling architecture of the city

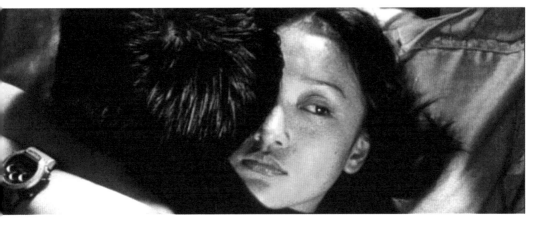

serves to represent Lan's downward spiral into a state of despair, with Lou utilizing old buildings to create disquieting atmospherics: the sounds of crashing thunder, creaking floorboards and pouring rain reverberate around these decaying structures as Lan risks her sanity to come to terms with her traumatic past.

Lou returned to the noir territory of *Weekend Lover* with *Suzhou he*/*Suzhou River* (2000), which finds Shanghai now in the throes of globalization as it was filmed during a period of extensive urban regeneration. It tells the intertwined stories of two couples: Mardar (Jia Hongsheng) is a motorcycle courier and small-time criminal who becomes romantically involved with Moudan (Zhou Xun), the daughter of a wealthy businessman who he has been hired to ferry around town, while an anonymous videographer (Hua Zhongkai) is in a relationship with Meimei (also played by Zhou), who makes her living as a performer at a seedy bar. The celebrated opening of *Suzhou River* is comprised of footage shot by the videographer as he travels down the titular creek by barge, recording the hard existence of those who work on the waterway, while also capturing occasional glimpses of the new structures that characterize the city's commercial centre. Signs of prosperity are largely sidestepped by the narrative that follows, as a misguided kidnapping plot and the subsequent search for lost love takes in dilapidated factory structures that await demolition, cramped apartments and the Happy Tavern, where Meimei's exotic mermaid routine serves to enchant drunken spectators.

Zi hudie/*Purple Butterfly* (2003) is Lou's final Shanghai film to date, a thriller that recreates the city of the 1930s to tell a suspenseful espionage story set in the lead-up to the Second Sino-Japanese War. Working with a substantial studio budget, Lou mounts a handsome period piece that concerns Xin Xia (Zhang Ziyi), a member of the titular underground resistance group which is committed to fighting the growing Japanese influence in China. In order to dismantle the group, the Japanese government has transferred intelligence officer Itami (Toru Nakamura) to run their Shanghai office, a decision that Purple Butterfly leader Xie Ming (Feng Yuanzheng) seeks to take advantage of as Xin Xia had an affair with Itami in Manchukuo, prior to the war. Xie Ming sends Xin Xia to reconnect with Itami in the hope of gaining inside information, but this plan has tragic consequences. In-keeping with its genre, *Purple Butterfly* frames Shanghai as a space of secrets and suspicion. Its characters find their allegiances undermined by personal feelings which threaten to rupture their respective organizations, while the city becomes a treacherous labyrinth that only the stealthiest operatives can successfully navigate.

Following his fourth feature, Lou would leave Shanghai to explore the urban fabric of other cities: Beijing in *Yihe Yuan*/*Summer Palace* (2006), Nanjing in *Chun feng chen zui de ye wan*/*Spring Fever* (2009) and Wuhan in *Fucheng mi shi*/*Mystery* (2012), with an excursion to Paris for *Love and Bruises* (2011). However, these works of doomed romanticism and social unease continue to evidence a wonderfully sensuous quality which singles Lou out as a truly Shanghainese film-maker. ✤

Lou's sustained focus on Shanghai is relatively unique, as is the manner in which he frames the city as a space of chance encounters and sexual desire.

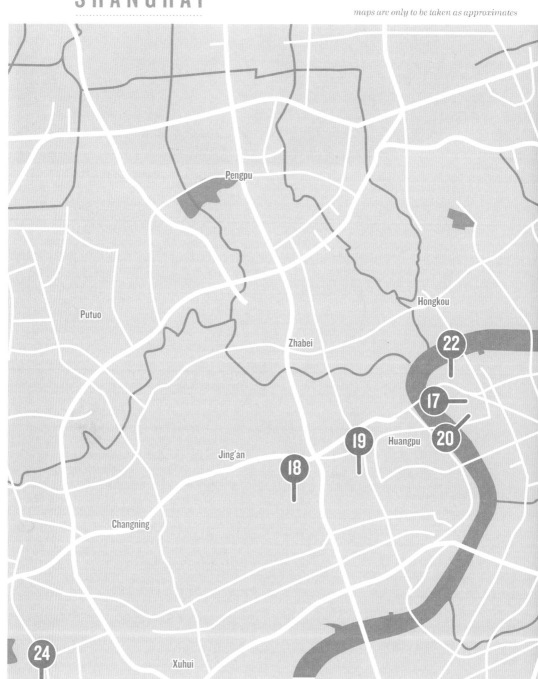

SHANGHAI LOCATIONS
SCENES 17-24

17.
GO FOR BROKE (2001)
Lujiazui Development Showroom, 15 East
Lujiazui Road, Pudong New Area
page 52

18.
SHANGHAI PANIC (2001)
Piano Bar Club, 172 Mao Ming Nan Road,
Luwan District
page 54

19.
SHAOLIN SOCCER (2001)
Lane Crawford store, Shanghai Times
Square, Huaihai Road, Luwan District
page 56

20.
CODE 46 (2003)
Shanghai Grand Hyatt Hotel, Jin Mao
Tower, 88 Century Avenue, Lujiuzui, Pudong
New Area
page 58

21.
2046 (2004)
CGI rendering of a future cityscape modelled
on Pudong New Area
page 60

22.
GODZILLA: FINAL WARS (2004)
Oriental Pearl Tower, 1 Century Avenue,
Pudong New Area
page 62

23.
KUNG FU HUSTLE (2004)
Longchang Apartments, 362 Longchang
Road, Yangpu District
page 64

24.
EVERLASTING REGRET (2005)
Shanghai Film Park, 4915, Bei Song
Highway, Chedun, Songjiang District
page 66

GO FOR BROKE/HENG SHU HENG (2001)

Lujiazui Development Showroom,
15 East Lujiazui Road, Pudong New Area

GO FOR BROKE is based on the real-life story of six laid-off workers from
state-owned companies who strived to make it big in the private sector
against all odds. Zhang Baozhong, a middle-aged unemployed worker starts
a private home-renovation company with help from five friends who have
also lost jobs. The film recreates the fate of the six workers as their company
goes through ups and downs, at one time nearly going bankrupt when
they are cheated in a construction project scam. However, they never lose
hope, and with the lucky circumstance of winning a lottery ticket, rescue
themselves from bankruptcy. Instead of hiring professional actors, director
Wang Guangli asked the real people who went through the experience to
re-enact their own story: the characters wear their own plain clothing and
act out their fate in Shanghainese dialect. This scene depicts the six workers
cheerfully heading for a draw in a television show where the amount of their
lottery win is to be decided. They all wear same red polo shirts to enhance
solidarity and drive through Lujiazui, a rapidly developing locality within the
Pudong New Area. For the six workers, Lujiazui represents their unceasing
hope in China's newly emerging opportunities. The contrast between the
Former Residence of Chen Guichun, the only old building that still exists
in the area, and the skyscrapers in the background, highlights the changes
that Shanghai and its residents have gone through in the era of reform and
opening up. ➻*Seio Nakajima*

Photo © Jiahui Xu

Directed by Wang Guangli
Scene description: Joyful minibus ride to a lottery draw
Timecode for scene: 0:54:18 – 0:55:08

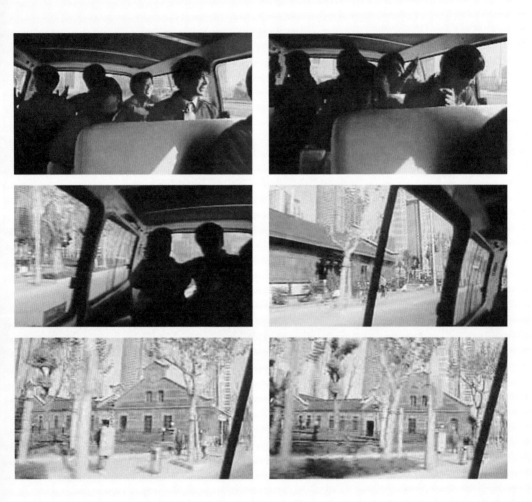

SHANGHAI PANIC/ WO MEN HAI PA (2001)

LOCATION *Buddha Bar, now Piano Bar Club,*
172 Mao Ming Nan Road, Luwan District

THE FIERCELY CONTROVERSIAL *Shanghai Panic* was directed by Andrew YS Cheng, who functioned as a one-man crew, also taking on the duties of writing, producing and editing. It was adapted from the 1998 novel *We Are Panic* by the Chinese literary wild child Mian Mian, with the rebellious writer also playing the main character of Kiki. The film boldly tackles a myriad of sensitive social issues (AIDS, drug abuse, homosexuality, prostitution) and was banned almost as quickly as it was released. At the beginning of the film, a group of friends – Bei (Li Zhinan), Kiki and Casper (Wenyan He) – gather outside Buddha Bar, a small nightclub located in Mao Ming Nan Road, one of Shanghai's most famous after-hours areas, then plan to purchase some ephedrine from a nearby 24-hour pharmacy. According to Bei, this cheap pill works very well as a club drug. They obtain two bottles and, after being joined by another member of their social circle, Fi Fi (Yang Yuting), share the pills at the nightclub. This is just another night out for this young generation who are experiencing the rapid economic growth and the emergence of consumer culture in China. They seem to be happy, but this particular group of young people are actually products of poverty and broken families, so they feel fragile and lost. The only way for them to feel safe is to spend time together at a private space like Buddha Bar where they can achieve a mutual state of intoxication. ⁕ **Wei Ju**

Directed by Andrew YS Cheng
Scene description: Friends hit the Shanghai club scene
Timecode for scene: 0:00:37 – 0:05:02

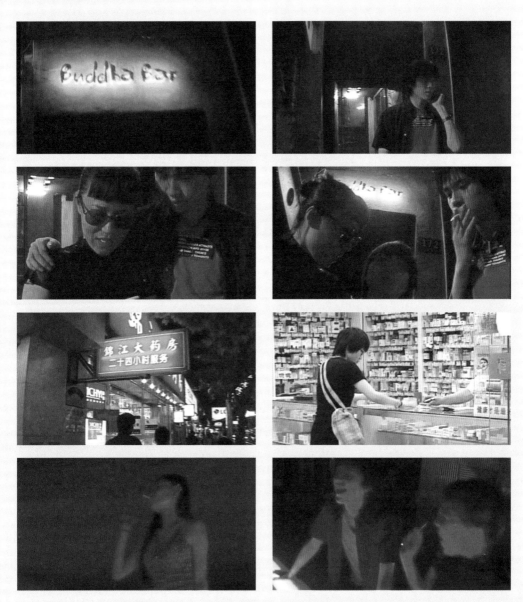

SHAOLIN SOCCER/SIU LAM JUK KAU (2001)

*Lane Crawford store, Shanghai Times Square,
Huaihai Middle Road, Luwan District*

'**KUNG FU.** We bring its power to soccer.' *Shaolin Soccer* combines kung
fu with an underdog sports narrative to form a genre hybrid that would
subsequently influence *Kung Fu Dunk* (Chu Yen-ping, 2008). This digital
effects extravaganza largely emphasizes outlandish football action, but
a far different scene that takes place in a Lane Crawford store is found
halfway through. Earlier in the film, Mighty Steel Leg Sing (Stephen Chow)
immediately recognizes Mui (Zhao Wei), a humble maker of sweet buns, as a
kung fu master, and is drawn to her, even complimenting her on her not-so-
obvious beauty. Surface appearances matter little in this film, whether they
are those of Sing's teammates (the nerdy Iron Shirt, the now ironically-named
Light Weight) or Mui. Once the assembled team of Shaolin masters are
ready for the Super Cup tournament, our erstwhile hero barters his janitorial
services for a date with Mui in the store after hours. Both Sing and Mui seem
out of place among the surrounding luxuries and this tender encounter is
reminiscent of the skating rink scene in *Rocky* (John G. Avildsen, 1976). Like
the Aigner store location which bookends the film, the Lane Crawford store
symbolizes China's emerging love affair with consumerism, as evidenced
by Mui's fascination with the dresses on display. Despite the additional
placement of Lane Crawford ads in the Super Cup finale, this store was closed
in 2006, with representatives citing its location as the problem.

↬ *Zachary Ingle*

Photo © Jiahui Xu

Directed by Stephen Chow
Scene description: Sing restores confidence in a 'beautiful kung fu master'
Timecode for scene: 0:59:05 – 1:01:52

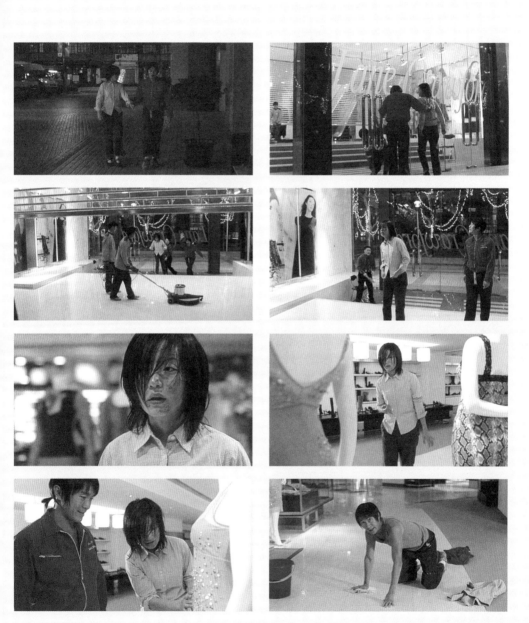

Images © 2001 Star Overseas

CODE 46 (2003)

Shanghai Grand Hyatt Hotel, Jin Mao Tower, 88 Century Avenue, Lujiuzui, Pudong New Area

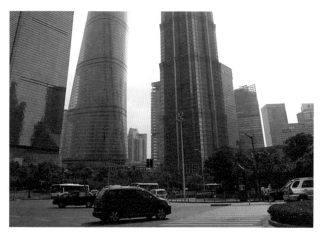

PREDOMINATELY SHOT on location in the Bund–Pudong district, Michael Winterbottom's science fiction love story *Code 46* skilfully utilizes the cityscape of this prosperous district as a setting for a film that vividly anticipates a Shanghai which will be transformed by transnational influences and technological advances. Situated in the heart of the New Area, the Grand Hyatt is contained within the 53rd to 87th floors of the Jin Mao Tower. As Detective William Geld (Tim Robbins) arrives in the building foyer and treks through the expanse of the spiral twists of the atrium to get to his room, Winterbottom takes advantage of the hotel's inspired design to enforce a futuristic semblance to the scene. While he relaxes and indulges in a virtual reality game, the encompassing vista, permeated with hyper-modern landmarks such as the Oriental Pearl Tower, continues the inspired use of contemporary locations to imply a world of tomorrow. The haunting beauty of the misty early morning skyline, crowded with extravagant high-rise buildings, makes for a stark contrast with the clean minimalism of the hotel interiors. Up until the early 1990s, the New Area was principally agricultural land. Now a designated Special Economic Zone designed to boost local culture and international commerce, it's not hard to see why the director chose these mega structures to incite his unique vision. Thanks to ambitious redevelopment, both the Jun Mao Tower and the Oriental Pearl Tower now stand as proud symbols of a district aesthetically characterized by its bold futurist architecture. **»Dave McCaig**

Photo © Jiahui Xu

Directed by Michael Winterbottom
Scene description: Checking-in
Timecode for scene: 0:04:37 – 0:05:32

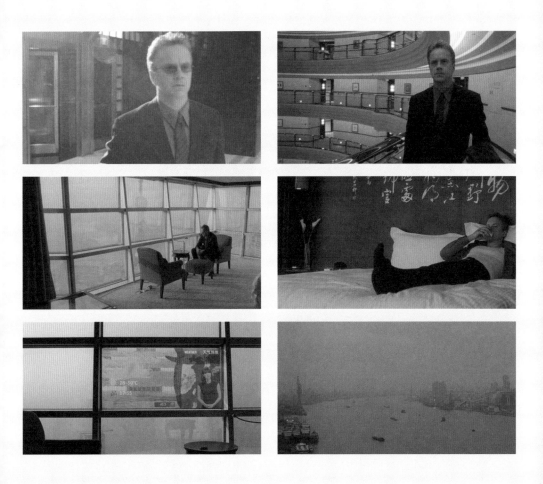

2046 (2004)

CGI rendering of a future cityscape modelled on Pudong New Area

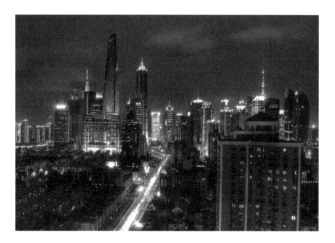

MOST OF *2046* takes place in Hong Kong and Singapore during the latter half of the 1960s. However, the film's protagonists desperately long to be in other places, or in other times, be it the past or the fictitious future of the science fiction story '2046', as written by Mr Chow (Tony Leung). The film begins with a high-speed train screaming through a tunnel. As the train slides amongst skyscrapers, high above the ground, the voice-over explains that this is the year 2046. Then, an extreme long-shot shows a vast, futuristic city dominated by a multi-level train system, not unlike the city in *Metropolis* (Fritz Lang, 1927). The vibrant, unreal colours enhance an eerie sense of alienation. A giant LG sign provides a familiar corporate fixture, and the more humanely proportioned street images that follow counterweigh the strangeness of this future city. Suddenly and briefly, a building resembling Shanghai's looming Jin Mao skyscraper comes into the left of the frame. To give his digital effects artists a sense of how he wanted his city of the future to look, director Wong Kar-wai took the team on a tour of Shanghai and other major Chinese cities, with hundreds of pictures being taken for reference. Although much of the final result has a dense and hazy quality, Shanghai remains a ghostly presence. The prestige of *2046* and various reports of its production method have served to enhance Shanghai's status as a city to which one looks for a glimpse of the future. ➼***Bjarke Liboriussen***

Photo © Wikimedia Commons

Directed by Wong Kar-wai
Scene description: Welcome to the city of the future
Timecode for scene: 0:01:44 – 0:02:41

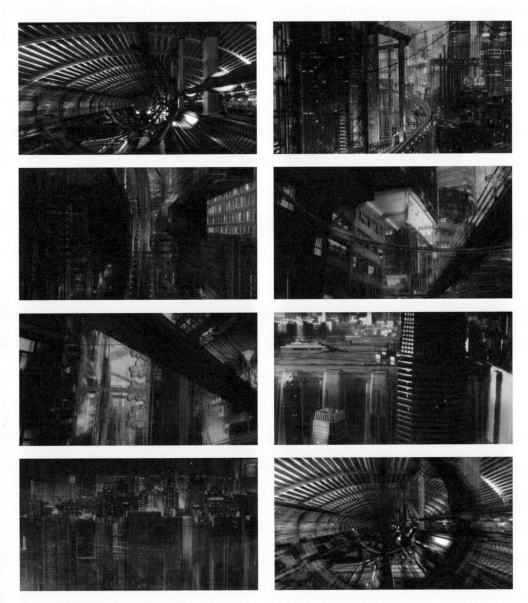

Images © 2004 Jet Tone Films

GODZILLA: FINAL WARS/ GOJIRA: FAINARU WOZU (2004)

LOCATION *Oriental Pearl Tower, 1 Century Avenue, Pudong New Area*

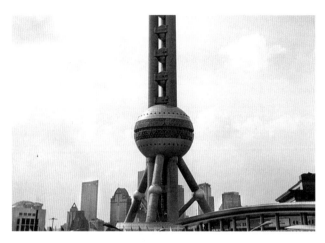

GODZILLA: FINAL WARS is the 28th entry in the Godzilla series, and it marked the 50th anniversary of the first *Godzilla* film, which was released in 1954. This instalment is set in the near future and finds alien invaders, the Xiliens, infiltrating the Earth Defence Force (EDF) while secretly controlling the attacks by monsters on the planet. As the anniversary film, *Godzilla: Final Wars* pays homage to the Toho Studios back catalogue by featuring fifteen monsters with Mothra, Rodan and Anguirus appearing alongside Godzilla. The film also features a number of popular EDF battleships including Gotengo, Karyu, Rambling and Eclair. As in other Godzilla films, the highlights are scenes in which Godzilla and the other monsters destroy famous international landmarks or locations. This scene takes place in the Bund and the Pudong New Area. The spaceship Karyu fights with Anguirus, who is in the midst of a destroying spree. Karyu loses control after being attacked by Anguirus and flies right into the Oriental Pearl Tower. This structure is a radio and television tower, located in the Lujiazui district of the Pudong New Area, right across from the Bund by the side of the Huangpu River. It is a major symbol of Shanghai as one of the powerhouse cities in China's rapidly developing economy. Now, the Oriental Pearl Tower has joined the ranks of the famous towers around the world that have been destroyed in the *Godzilla* series, including the Tokyo Tower in Japan and the Sydney Tower in Australia. **•• Seio Nakajima**

Photo © Jiahui Xu

Directed by Ryuhei Kitamura
Scene description: *Godzilla destroys the Oriental Pearl Tower*
Timecode for scene: *0:58:37 – 0:59:13*

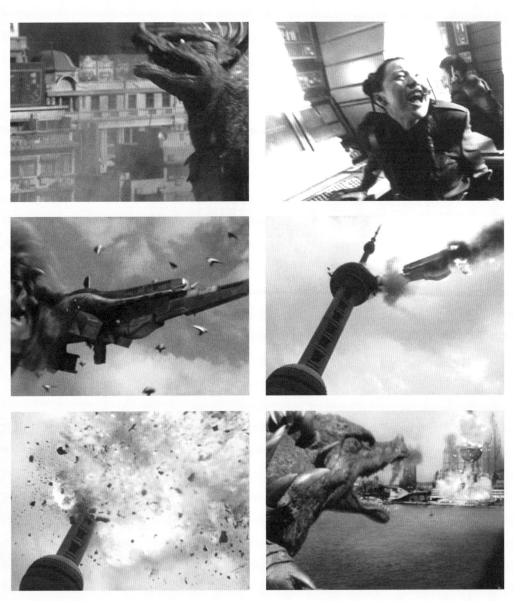

KUNG FU HUSTLE/GUNG FU (2004)

LOCATION

Soundstage recreation of the Longchang Apartments, 362 Longchang Road, Yangpu District

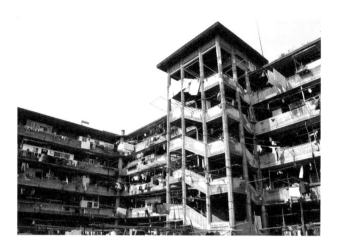

IN THE ACTION-COMEDY *Kung Fu Hustle*, turmoil grips Shanghai in the 1930s. Various gangs vie for power, the most feared of which is the Axe Gang, led by Brother Sum. One day, two troublemakers, Sing (Stephen Chow) and Bone (Chi Chung Lam), come to the Pig Sty alley, impersonating members of the Axe Gang to gain respect. Their plan fails, and Sing's antics attract the real gang to the scene. In the massive brawl that ensues, more than fifty gangsters are defeated by three tenants who are martial arts masters. Pig Sty Alley is a high density neighbourhood, which seems like a village, with its public baths, breakfast shops, grocers and tailors. Although Pig Sty Alley reflects the brutal lives of the lower class, it also constitutes a united community. When the Axe Gang and the Beast threaten the alley, its inhabitants come together to confront their enemies. This set was inspired by director/star Chow's childhood neighbourhood and the earlier *Chat sup yee ga fong hak/The House of 72 Tenants* (Chor Yuen, 1973), which was adapted from the 1945 Shanghai stage comedy of the same name. The Long Chang Apartment is considered to be the real-life version of Pig Sty Alley. It was designed by an English architect as a police station in the international concession area in the 1920s. In the 1950s, it was turned into a residential building, housing around 250 families. In 2004, the Longchang Apartments were registered as cultural relics by the local authority. **•• *Wei Ju***

Photo © Jiahui Xu

Directed by Stephen Chow
Scene description: Attempted blackmail at Pig Sty Alley
Timecode for scene: 0:12:26 – 0:24:34

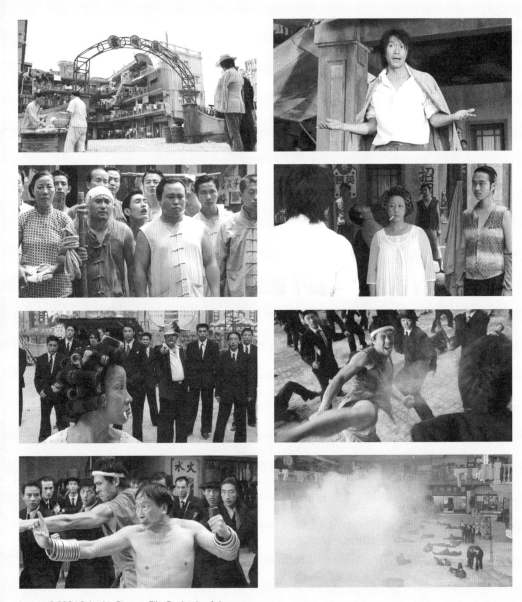

Images © 2004 Columbia Pictures Film Production Asia

EVERLASTING REGRET/CHANGHEN GE (2005)

LOCATION *Shanghai Film Park, 4915, Bei Song Highway, Chedun, Songjiang District*

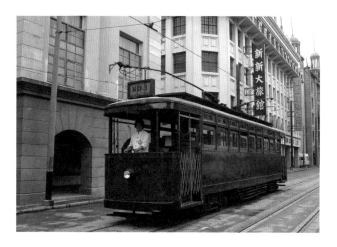

BASED ON WANG ANYI'S acclaimed 1995 novel *The Song of Everlasting Sorrow*, Stanley Kwan's third film engages with the vicissitudes of Shanghai and throws the spotlight on one female character, Wang Qiyao (Sammi Cheng). Nevertheless, Wang's fate and legend seem to bear no essential connection with the zeitgeist of those historical moments of her city from the final days of Kuomintang's rule of the People's Republic China in the 1980s. Rather, she keeps her own pace against the tides and currents of life even at a time of political turmoil and social transformations, while her encounters with several men are also foregrounded in Kwan's adaptation. The film is proportionally shot at Shanghai Film Park at Songjiang County, where replicas of the classic architecture of Nanjing Road have been constructed for production purposes. Even though the novel treats Shanghai as its main character, elaborating on details of the *shikumens* and *longtangs*, Kwan's film favours interior scenes set in Wang's apartment and other places of rendezvous and intimacy. The film starts with Qiyao visiting the set of an unknown film with her best friend Lili (Su Yan). She is so mesmerized by the cinematic setting that she even tries to relax on a bed by the window, peeking out of it in order to have a glimpse of Shanghai by night in its abstract profile. Her reverie is suddenly disturbed when the props start to move, which also makes the audience realize that this sequence is all about the art of illusion.

↝ Ma Ran

Directed by Stanley Kwan
Scene description: Lost on a film set
Timecode for scene: 0:01:01 – 0:01:58

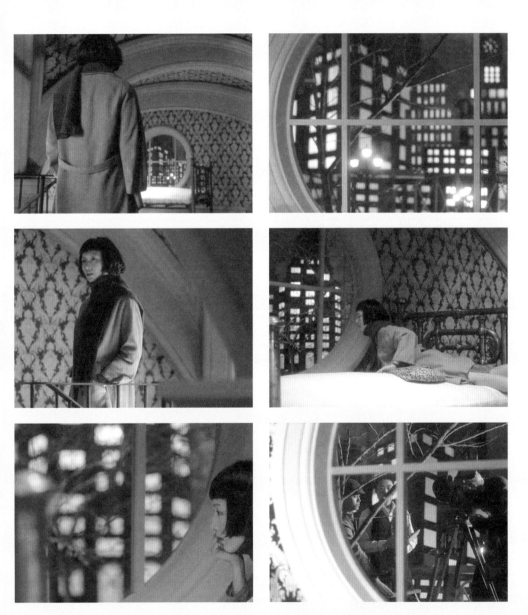

SPOTLIGHT

SIXTH GENERATION SHANGHAI

Text by
DAVE
MCCAIG

Politicizing the Aesthetic

THE CINEMATIC OUTPUT of China's Sixth generation considers the rapid growth of the vibrant metropolis that is Shanghai. These films demonstrate a collective willingness to interrogate the consequences of the radical cultural, economic, political and aesthetic transformations that have shaped the city with regards to the individual. As China continues to embrace postsocialism in the current stage of advanced globalization, it is hard to believe that, in 1985, Shanghai, a municipal now abound with iconic hyper-modern structures, only boasted a single skyscraper. An accelerated process of urban evolution has ensured that Shanghai now boasts more skyscrapers than Manhattan and city planners continue to redevelop entire districts as the enthusiastic rebranding of Shanghai as the 'City of the Future' continues apace.

Long the most cosmopolitan of the mainland's

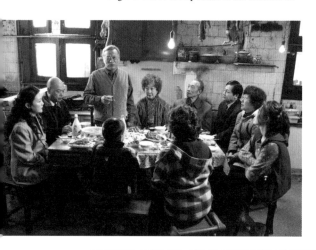

cities, Shanghai poses a seductive draw for these film-makers whose formative years were shaped by China's transition from socialism to capitalism. The city remains off-screen in *Quing hong/ Shanghai Dreams* (Wang Xiaoshuai, 2005) but is idealized in the memories, hopes and dreams of its characters as a bustling chic Utopia. These characters imagine a new life in the Shanghai of the 1980s with hopeful optimism: a stark contrast to their despondent existence in Guiyang, a bleak and insular inland town. Predominantly viewed through the experiences of teenager Quing hong (Gao Yuanyuan), the influence of western culture is seen to be seeping through. In the town hall, fancifully attired youths stare awkwardly at the edge of a dance floor as disco music entices their more confident peers to break out into kinetic and suggestive moves while requited affection is pursued through materialistic gifts such as expensive footwear.

Perhaps the most successful in illustration of the dramatic contrast between established custom and the new Shanghai can be found in *Tuan yuan/Apart Together* (Wang Quan'an, 2010), an emotionally underplayed melodrama that explores the implications of the volatile nature of national politics on the individual. The narrative focuses on former soldier Lui Yansheng (Ling Feng) as he returns to his native Shanghai on an officially approved tour and attempts to reunite with his wife, Qiao Yu-e (Lu Yan) and their son. After over fifty years of political exile in Taiwan, Lui views the dramatic changes in his home city with disarming awe. Journeying on sightseeing tours that take in the modern districts, Wang extorts an alarming animosity towards the sheen of these

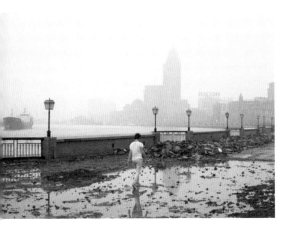

new areas. Meanwhile, the unsophisticated charms of the traditional *longtang* (alleyway) communities warrant a determined endorsement. This is accentuated by cinematographer Lutz Reitemeier's artful interpretation and Lui's role as a cipher for the directors' forthright sentiments. Distinguished by warm lighting, vibrant surroundings and tight framing, family life in the *longtang* neighbourhoods is presented with affectionate fascination. While characters adjust to difficult circumstances and develop new bonds, the comforts of familiarity are to be found in these tightly packed residential areas. Meanwhile, scenes of newly developed areas emphasize the alien nature of eccentrically designed tower blocks with more naturalistic lighting used to emphasize the cold exteriors of concrete and chrome.

Demonstrating a proclivity for synthesizing documentary and arthouse aesthetics, *Suzhou he/ Suzhou River* (Lou Ye, 2000) is a self-consciously stylish genre piece that explores the unstable relationship between disfranchised young lovers. The area surrounding the creek is portrayed as a decaying, semi-industrialized concrete expanse. Neon-lit bars populated by shady underworld figures and the promise of requited love provide a temporary respite for the film's protagonists. During filming, Shanghai was on the cusp of re-branding itself in the wake of economic renewal: the Suzhou Creek rehabilitation project was initialized with the old factories

In 1985, Shanghai, a municipal now abound with iconic hyper-modern structures, only boasted a single skyscraper.

and desolate warehouses that litter the *mise-en-scène* beginning to be populated by artists who utilized the desolate buildings as studios. By the time that *Suzhou River* was released, the murky hues that constituted the river had been sanitized, with gentrification emerging as commercial offices and luxury homes sprung up along the bank. An ambitious project, the latest phase of the rehabilitation scheme came to completion in time for the Shanghai World Expo in 2010. Today, the area surrounding the creek is strongly promoted as a tourist attraction. With the implementation of 95 greenbelts at the banks of the river and an aesthetically striking combination of new buildings and re-appropriated warehouses, this modern area is now virtually unrecognizable in *Suzhou River*. Lou's film serves as a record of a bleak urban expanse now consigned to fading memory.

The circumstances surrounding the production of *Hai shang chuan qi/I Wish I Knew* (Jia Zhangke, 2010) and its compelling portrayal of Shanghai's tumultuous past and ambitious present make it a fascinating Sixth Generation milestone. Although many cultural critics envisaged this documentary as evidence of the director finally selling out and replacing the passion of political art-cinema with the hollowness of a state commission, Jia, who had most of his early underground work banned by the Chinese authorities, accepted the assignment on the condition that he be granted artistic freedom. Jia presents Shanghai's' modern history through a combination of interviewee testimony, archive footage from the socialist era, re-enactments and observational documentary. By doing so, he accomplishes an enlightening treatise that unearths the social-political background of many of Shanghai's iconic avenues and monuments. Typical of his directorial style, wide shots and long takes capture the majesty of parkland areas such as the Yuan Gardens, the many semi-assembled themed pavilions of the Expo and modern *longtang* life. These preserved spaces are complimented by recent constructions that have revitalized predominately agricultural land such as the Shanghai International Racing Circuit and the otherworldly skyline of the Bund–Pudong Special Economic Zone. Linking these segments, actress Zhao Tao, dressed simply in white and invisible to those around her, scrutinizes Shanghai as it evolves. Her confused disconsolation at the erosion of traditional ways of life is reminiscent of a disposition shared by the Sixth Generation and symbolic of the subversive questioning that continues to distinguish their work. ✢

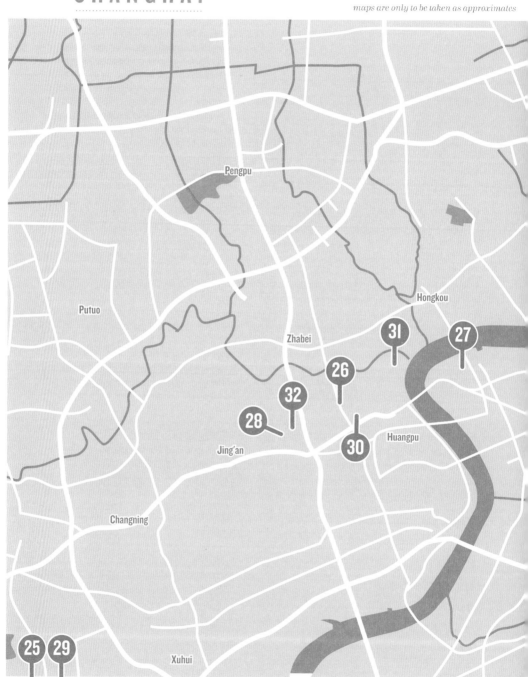

SHANGHAI LOCATIONS
SCENES 25-32

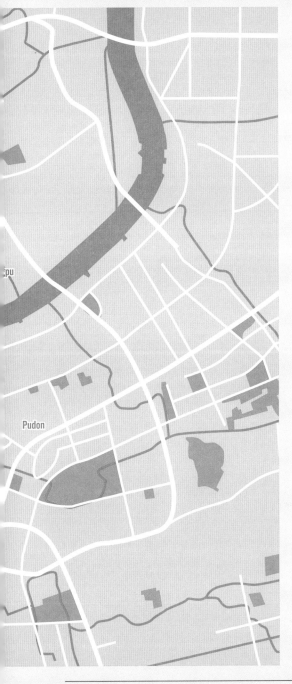

25.
PERHAPS LOVE (2005)
Shanghai Film Park, 4915, Bei Song
Highway, Chedun, Songjiang District
page 72

26.
THE WHITE COUNTESS (2005)
Shanghai Art Museum, People's Square,
Huangpu District
page 74

27.
MISSION: IMPOSSIBLE III (2006)
Bank of China Tower, Lujiazui Ring Road,
Pudong District
page 76

28.
NOSTALGIA (2006)
Shanghai Min Li High School, Dazhongli,
Jing'an District
page 78

29.
THE PAINTED VEIL (2006)
Shanghai Film Park, 4915, Bei Song
Highway, Chedun, Songjiang District
page 80

30.
STREET LIFE (2006)
Guangxi North Road, Huangpu District
page 82

31.
THE LONGEST NIGHT IN SHANGHAI (2007)
Dian Chi Road, Huangpu District
page 84

32.
LUST, CAUTION (2007)
First Siberian Fur Store, West Nanjing Road,
Huangpu District
page 86

PERHAPS LOVE/RUGUO AI (2005)

LOCATION *Shanghai Film Park, 4915, Bei Song Highway, Chedun, Songjiang District*

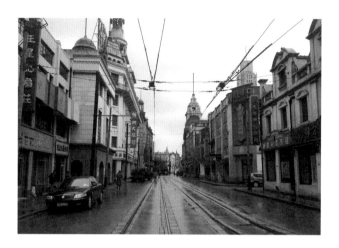

WHILE DIRECTOR PETER CHAN may not fully embrace the idea that *Perhaps Love* is in essence a musical, he does experiment by interweaving song and dance elements with narrative in this dynamic drama. Also, this is a highly self-reflexive work about film-making and cinema. Ambitious actress Sun Na (Zhou Xun) is seemingly a social climber who would sacrifice anything to achieve the success she desires. The main storyline follows a new film set in Old Shanghai that will star Sun with her boyfriend Nie Wen (Jacky Cheung) serving as both co-star and director. Unexpectedly, Sun finds out that another lead male role will be filled by Hong Kong star Lin Jiandong (Takeshi Kaneshiro), whom she was involved with ten years ago in Beijing, when she was a struggling cabaret singer and Lin was still an idealistic film student. The repressed relationship between Sun and Lin is further complicated by the fact that Nie's ambitious project is a love-triangle story set in a circus. Most of the film's Shanghai scenes were shot at the Shanghai Film Park, where replicas of landmarks of Shanghai in its Republican Era have been built. In one decisive scene for Nie's film, the circus owner that Nie himself plays flies trapeze with Sun Na, which is also featured as the turning point for the entangled relationship. The platform Nie jumps from is a replica of the clock tower of the Sun Sun Company, while the original building still stands on the Nanjing Road of today. ✒**Ma Ran**

Directed by Peter Chan
Scene description: *Trapeze stunt above replica Nanjing Road*
Timecode for scene: *1:26:03 – 1:34:45*

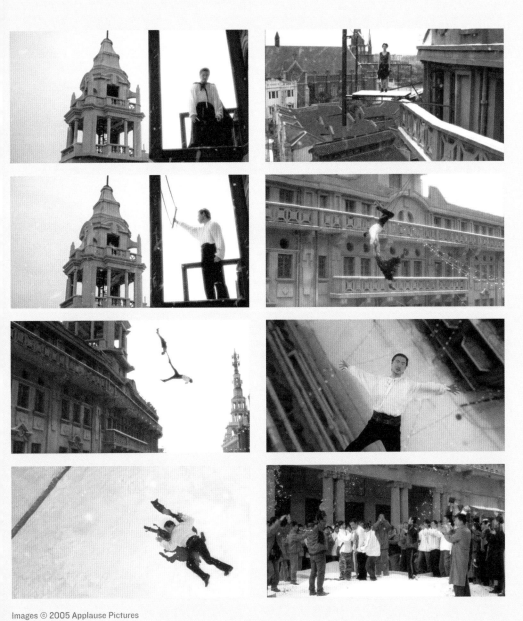

THE WHITE COUNTESS (2005)

Recreation of Shanghai Race Course, now Shanghai Art Museum, People's Square, Huangpu District

EVEN WITHOUT THE USUAL Ruth Prawer Jhabvala screenplay, Christopher Doyle's cinematography makes this overlooked entry in the Merchant-Ivory canon a worthwhile film, while it is also notable for being the last collaboration between director and producer. Most of the locations used in this depiction of Shanghai circa 1936–37 are from previous film and television sets, with the location discussed here also a recreation. When first meeting the mysterious Mr Matsuda (Hiroyuki Sanada), blind former American diplomat Todd Jackson (Ralph Fiennes) reveals his desire to open the 'bar of his dreams', but that it would take a successful 'flutter', betting everything that he owns on a horse, to do so. In this scene, Jackson does just that and has his stroke of luck. Bedecked in a white linen suit, Jackson does not sit in the grandstand, but instead mimics the actions of a jockey while he listens to the race in a tent. It is only when he reveals to Matsuda that his dream will be realized that the audience finally learns the outcome of the race. But even better than founding the titular, cosmopolitan club, he can now acquire the Countess Sofia Belinskya (Natasha Richardson) as his 'centrepiece'. The original racetrack, near the People's Park and People's Square was torn down decades earlier so this scene was shot in another athletics stadium. It has a somewhat claustrophobic feel, as it had to be filmed in such a manner in order to avoid catching glimpses of the contemporary Shanghai cityscape.

❧ *Zachary Ingle*

Directed by James Ivory
Scene description: Fortune turns for Jackson
Timecode for scene: 0:31:48 – 0:36:58

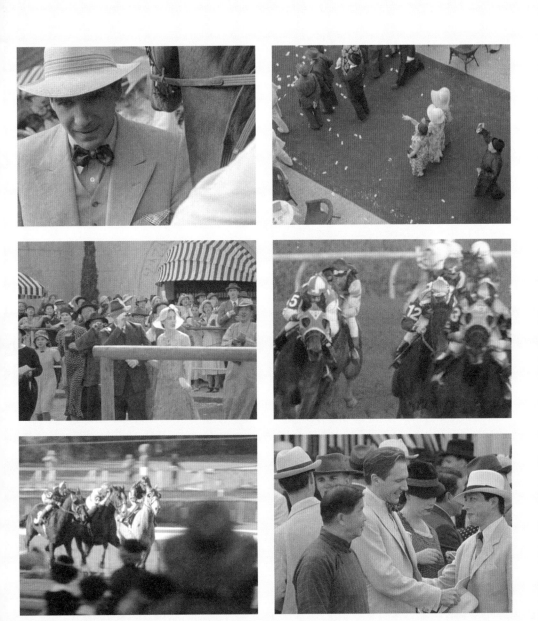

MISSION: IMPOSSIBLE III (2006)

Bank of China Tower, Lujiazui Ring Road, Pudong New Area

GLOBE-TROTTING British Secret Service agent James Bond may have visited Shanghai in *Skyfall* (Sam Mendes, 2012), but his American rival for box office supremacy, IMF operative Ethan Hunt (Tom Cruise), was the first superspy to hit town with *Mission: Impossible III*. As part of a desperate plan to rescue his civilian wife, who has been kidnapped by a vindictive arms dealer, Hunt must make a dangerous 200-metre leap from the 53-storey Bank of China Tower to the adjacent offices of the China Pacific Insurance Company. Fellow operatives Declan Gormley (Jonathan Rhys Meyers) and Zhen Lei (Maggie Q) run interference by blasting baseballs at the target building's security team while Hunt takes a running jump from the ledge of the tower, crossing the spectacular Pudong skyline via bungee cord, with director J. J. Abrams utilising the bright lights and gleaming architecture of the business district as a backdrop for vertiginous thrills. With the leap successfully completed, Hunt faces a more routine challenge in the form of armed security personnel, who he dispatches with customary efficiency while rapidly sliding down the structure's glass exterior en route to a suitable entry point. A return trip to Shanghai for this franchise is unlikely as the local censors were unhappy about scenes showing laundry hanging on bamboo poles. Nonetheless, the jaw-dropping stunt executed in *Mission: Impossible III* established the city as a prime location for global spectacle, with the Bank of China Tower, designed by the Japanese architectural firm Nikken Sekkei, positioned as its centrepiece. •❖ *John Berra*

Photo © Jiahui Xu

Directed by J. J. Abrams
Scene description: Ethan Hunt leaps into the danger zone
Timecode for scene: 1:23:53 – 1:30:11

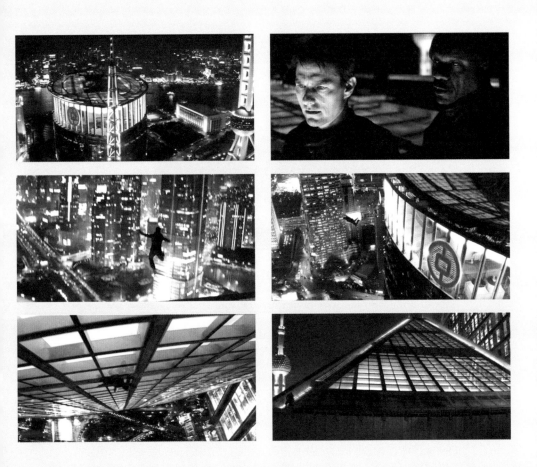

NOSTALGIA/XIANG CHOU (2006)

LOCATION *Shanghai Min Li High School, Dazhongli, Jing'an District*

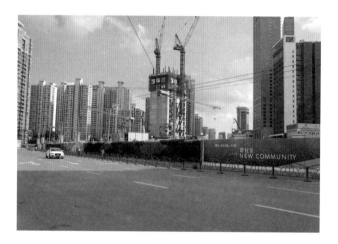

AS A SHANGHAI NATIVE, Shu Haolun dedicates his documentary *Nostalgia* to Dazhongli, a residential quarter next to West Nanjing Road. It was famous for being the city's largest cluster of *shikumen* (townhouse) residences and three generations of Shu's families lived there. This highly personal project was launched when Shu learnt that a Hong Kong developer had purchased the land of Dazhongli from the district government, aiming to developing it into a leisure and shopping complex. Despite the developer's promise of heritage preservation due to the historic value of Dazhongli, residents would be relocated as almost the entire residential area was ultimately bulldozed. This including House No. 3, Shu's old family residence where his grandmother was still living when he started shooting this documentary. *Nostalgia* offers a last glimpse of the disappearing neighbourhood, in which interviews with old neighbours, acquaintances and reminiscences of yesterday's Dazhongli are alternated with re-enactments of Shu's coming-of-age stories. Shu peeks out of the window of his high school classroom with the sight of connected red-brick rooftops suggesting an isolated island as this area is surrounded by an encroaching circle of skyscrapers. In the distance, behind the lifted curtain, we can see through the window of the grandmother's living room and observe the elderly residents playing mah-jong as if nothing could ever change their way of life. The gesture of looking is not simply about the confirmation of spatial distance as it is about temporal differentiation: it is the gaze directed at the disappearing subject. **⇢Ma Ran**

Photo ⓒ Jiahui Xu

Directed by Shu Haolun
Scene description: *Shu looks over Dazhongli from his old classroom*
Timecode for scene: 0:40:56 – 0:42:32

THE PAINTED VEIL (2006)

Shanghai Film Park, 4915, Bei Song Highway, Chedun, Songjiang District

THE PAINTED VEIL, a 1925 novel by the British author W. Somerset Maugham, has been adapted into three movies: in 1934 featuring Greta Garbo, in 1957 under the title *The Seventh Sin,* and this most recent version by John Curran. Although the book and previous adaptations are set in Hong Kong, recreating a vision of the city in the 1920s proved too difficult for the production team so the story of British bacteriologist Walter (Edward Norten) and his wife Kitty (Naomi Watts) was altered to take place in Shanghai. Representations of the British colonial presence in Shanghai function as a visual contrast to a remote cholera-stricken village shot on location in Guilin, Guangxi. In this context, Shanghai only plays a peripheral role; a vague reminder of Kitty's affair with another expatriate and a reference to Britain's dwindling influence in the region. Representations of London as the protagonists' geographical and cultural 'home' were, ironically, filmed in Shanghai Chedun Film Park. Kitty eventually returns to London where she raises her son Walter – a name given in honour of his father who tragically dies of cholera in China. In an apparent reference to the Russian photographer Alexander Rodchenko's technique of shooting the street from high vantage points, the last shot of the film depicts Kitty and Walter Jr's hand-in-hand crossing of a set of tram tracks. The tracks signify the beginning and the end of a journey as Kitty puts her complex past behind her to embark on a new chapter in life. ➻ *Marco Bohr*

Photo © Jiahui Xu

Directed by John Curran
Scene description: Moving On
Timecode for scene: 1:53:51 – 1:55:45

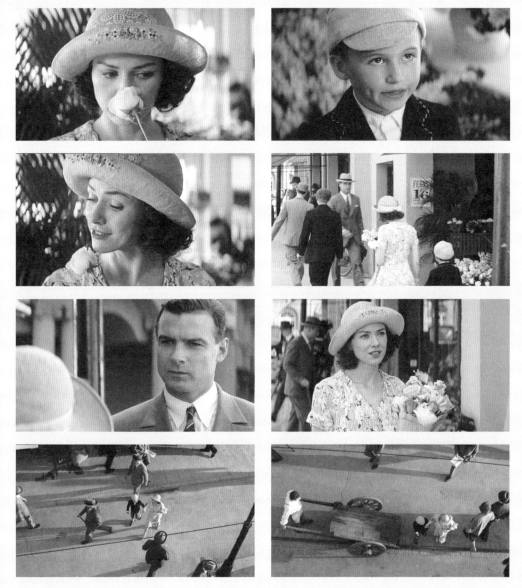

Images © 2006 Bob Yari Productions

STREET LIFE/NANJING LU (2006)

LOCATION *Guangxi North Road, Huangpu District*

STREET LIFE is a documentary that focuses on the homeless people who make a living by collecting bottles. It is a film that epitomizes the urbanization of Shanghai, a city of prosperity and starvation; of dazzling modernity and impoverished darkness; of the best of times and the worst. It is hard to imagine that in Guangxi North Road, only several steps from Nanjing Road, exists a growing number of individuals who will fiercely compete to retrieve one single bottle. Guangxi North Road is a narrow and messy area of Shanghai with small restaurants, a bustling marketplace and old buildings, populated by local residents and beggars. It is a place more frequented by the natives who enjoy the charms offered by the city at night. Although it is not as magnificent as Nanjing Road, the lights of Guangxi North Road are always shining, promising a relatively cheap area in terms of nightlife. In this scene, the collectors settle here to enjoy themselves, chatting and making fun of one another. These uncultivated citizens and migrants are largely ignored by the more prosperous people who regularly frequent the area: they talk about trivial matters while savouring their beer and waiting for the sunrise of tomorrow. Each evening, they try to emulate the kind of Shanghai residents that they can never be during daylight hours. They are protected by the night while relaying their stories, which are imbued with their continuing hopes but also informed by their tortured and often violent existence.

•• *Wenfei Wang*

Photo © Jiahui Xu

Directed by Zhao Dayong
Scene description: Bottle collectors relax after another hard day's work
Timecode for scene: 1:20:07 – 1:23:00

THE LONGEST NIGHT IN SHANGHAI/ YE SHANG HAI (2007)

LOCATION *Dian Chi Road, Huangpu District*

ZHANG YIBAI'S romantic-comedy *The Longest Night in Shanghai* presents the city as a beautifully cosmopolitan and socially vibrant metropolis. Taxi driver Lin Xi (Zhao Wei) finds visiting-Japanese-stylist Naoki Mizushima (Masahiro Motoki) lost in the streets of Shanghai and offers to chauffeur him around the city. Both are dealing with personal problems, and they enjoy one another's company. However, neither Lin Xi nor Naoki has a grasp of the other's language, so they find the best way to communicate is by writing on the car window or the street with lipsticks. Eventually, the whole street is covered with red words and sentences. Not only do they encourage one another to overcome their respective problems, they also develop mutual feelings. The next morning, when Naoki realizes he is developing a bond with Lin Xi, he returns to Dian Chi Road and sees a cleaning vehicle washing away their words, but is surprised to find Lin Xi standing at the other side of the street. Dian Chi Road is a small street near the Bund in Huangpu district. Unlike the other locations featured the film, it is a quiet place which provides some peace to two people at a time of emotional suffering. Throughout the rest of the film, the main characters wander the city feeling adrift and trying to avoid dealing with their problems, but in the scene, they calm down, finding the courage to express themselves that will be necessary if they are to face their difficulties.

•• **Wei Ju**

Photo © Jiahui Xu

Directed by : Zhang Yibai

Scene description: *Chinese taxi driver and Japanese stylist communicate with lipstick*
Timecode for scene: 1:18:51 – 1:25:19

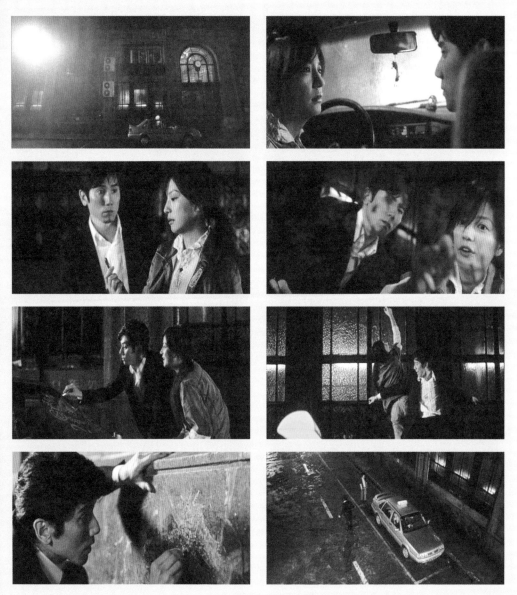

Images © 2007 Shanghai Film Studios

LUST, CAUTION/SE, JIE (2007)

LOCATION *Soundstage recreation of the First Siberian Fur Store, West Nanjing Road, Huangpu District*

ANG LEE'S espionage thriller *Lust, Caution* is adapted from the 1979 short story of the same name by the Chinese novelist Eileen Chang. Set from 1938 to 1942, it revolves around a group of young patriots who join the resistance movement and attempt to assassinate the head of the secret police department, Mr Yee (Tony Leung). Chang's short story is based on real events, as secret agent Zheng Ping Ru was assigned the mission of assassinating the politician Ding Mocun in 1939. Former drama student Wong Chia Chi (Tang Wei) has been assuming the identity of Mrs Mai, the elegant wife of the owner of a Hong Kong trading company, to get close to Mr Yee. She has embarked on an affair with the special agent in order to lure him into a trap. In this scene, she asks Mr Yee to accompany her to the fictional Chandni Chowk jewellery shop on Jing'an West Road, since renamed West Nanjing Road. Outside the shop, members of the resistance are waiting to kill Mr Yee. However, when store proprietor Khalid Saiduddin (Anupam Kher) presents Wong Chia Chi with the diamond ring that Mr Yee has bought for her, she is overwhelmed by his love and urges him to leave at once, thereby sabotaging the assassination plot. This set was actually modelled on the First Siberian Fur store, an exclusive luxury goods outlet. The company was established in 1925 but is now one of many time-honoured brands facing tough competition from the influx of international products. **⟿ Wei Ju**

Photo © Jiahui Xu

Directed by Ang Lee
Scene description: Wong Chia Chi urges Mr Yee to evade assassination
Timecode for scene: 2:17:24 – 2:21:05

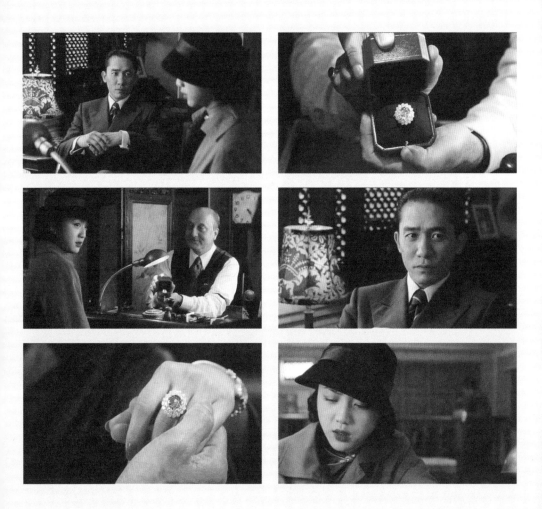

SCI-FI SHANGHAI

City of the Future

Text by
JOHN
BERRA

THE FUTURISTIC architecture of Shanghai, particularly its Bund–Pudong area, has served as both inspiration and location for directors operating in the science fiction genre, with the high-rise structures that dominate its skyline proving to be the ideal model for directors who wish to locate the world of tomorrow in the cityscape of today. Just as China recently overtook Japan to become the world's second-largest economy, Shanghai has now superseded Tokyo as the city that best represents the futurist potential of the international metropolis. It is within the context of the science fiction genre that the imaginative potential of the city is particularly evident, with directors using contemporary Shanghai as a basis for their future visions. When the Hong Kong auteur Wong Kar-wai required a model for the future world of *2046* (2004), he found it in the spectacular Bund–Pudong skyline, which served as a model for CGI rendering. Other directors have been similarly inspired, with Shanghai becoming a genre fixture in both independent and major Hollywood studio projects, reflecting not only China's rise in terms of international film

production, but Shanghai's specific position as a location option in the global era.

Andrei Tarkovsky famously travelled with a small crew to the Japanese capital to utilize its highway to suggest the urban landscape of the tomorrow for *Solaris* (1972), but when Michael Winterbottom required a found future for his science fiction love story *Code 46* (2003), he chose Shanghai. By that point, Shanghai had become the financial hub of East Asia due to the economic reforms introduced by Deng Xiaoping and also a cityscape defined by architectural progression. By shooting on location in Shanghai, even with a limited budget, Winterbottom was able to realize a convincing vision of a future where people work at night due to exposure to direct sunlight being a health hazard, and a multitude of nationalities have relocated to the city in pursuit of employment opportunities at various industrial levels. The courtship between insurance fraud investigator William Geld (Tim Robbins) and factory employee Maria Gonzalez (Samantha Morton) navigates the neon-lit central area of Shanghai via walkways and subways, with the postmodern backdrop constituting a future metropolis where the geopolitical landscape has categorized urbanites as bureaucrats, drones or black-market drifters, with beggars left to struggle at the city limits. It's a disconcerting vision of dystopia which, in part, makes social projections based on the internationalized Shanghai of today.

At the opposite end of the budget scale, Shanghai has serviced such futuristic thrillers as *Ultraviolet* (Kurt Wimmer, 2006) and *Looper* (Rian Johnston, 2012). The former combines scenes shot around the city's business district with sets and costumes to suggest the world of 2078, when a global epidemic has caused infected individuals to develop superhuman strength, although they will die within twelve years of the virus taking effect. Violet (Milla Jovovich) is a

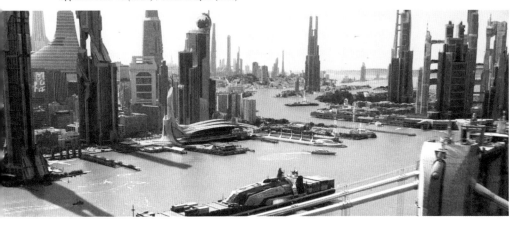

Above © 2012 Endgame Entertainment
Opposite © 2003 British Broadcasting Corporation

member of an underground resistance group that seeks to protect the infected from extermination by the government until a cure can be found. Both the plot and production background of *Looper* acknowledge China's economic status with the film being a joint venture between American backer Endgame Entertainment and Chinese partner DMG Entertainment. In the year 2044, Joe (Joseph Gordon-Levitt) is a professional killer operating in Kansas City whose targets are all people sent back in time from the future for termination. He plans to retire to Paris, but his boss Abe (Jeff Daniels) suggests that Shanghai would be a better idea, a reference to the film's creative development as Johnston swapped his original choice of future location from Paris to Shanghai at the insistence of his production partners. Instead of making a new life for himself in the French capital, Joe (played in the future scenes by Bruce Willis) instead winds up in Shanghai, where he drinks heavily, spirals into drug addiction, but eventually finds romantic redemption.

International audience awareness of Shanghai's significance as a global metropolis has been acknowledged by the manner in which the city has been utilized as a candidate for destruction in various science fiction blockbusters. *Armageddon* (Michael Bay, 1998) finds one of the world's biggest cities being eradicated in a mere two seconds by a large fragment from an asteroid belt that has been ruptured as

a result of a rogue comet, with the significance of this event forcing NASA to go public with its plan to stop this threat to planet Earth. The comic book adaptation *Fantastic Four: Rise of the Silver Surfer* (Tim Story, 2007) uses Shanghai for the climactic confrontation between the titular superheroes and arch nemesis Doctor Doom (Julian McMahon), who knocks the top off the Oriental Pearl Tower. *Transformers: Revenge of the Fallen* (Michael Bay, 2009) opens with Optimus Prime on a mission in Shanghai to track down the enemy Decepticons who remain at large following the first film in the series, resulting in a bombastic chase through the city streets. This location choice also reflects the growing importance of China's multiplex market, where the *Transformers* franchise has been enormously successful, with a clichéd nod to local culture as the robots burst through the wall of a small house where an elderly resident is eating a bowl of noodles.

The science fiction visions of Shanghai discussed in this essay are international productions, as China's film industry has so far been largely reluctant to invest in the genre due to strict censorship restrictions related to such narrative tropes as technological speculation and time travel. When the local industry did produce a science fiction spectacular in the form of *Kei hei hup/ Metallic Attraction: Kung Fu Cyborg* (Jeffrey Lau, 2010), the robotic action was located not in a major metropolis, but in a remote town. If the production of Chinese science fiction films becomes more frequent, Shanghai will surely feature at some point, but for the ever-increasing number of international directors who are using the city as a location for genre purposes, the future is now. ✣

Shanghai has now superseded Tokyo as the city that best represents the futurist potential of the international metropolis.

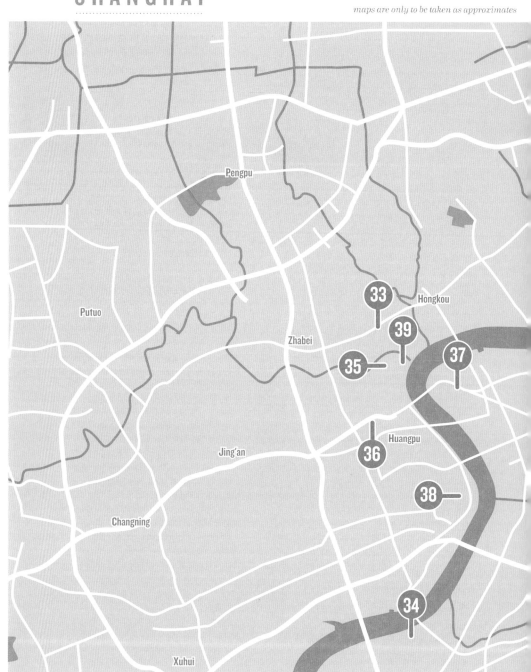

Pengpu

Putuo

Zhabei

33

Hongkou

39

35

37

Jing'an

Huangpu

36

38

Changning

34

Xuhui

SHANGHAI LOCATIONS
SCENES 33-39

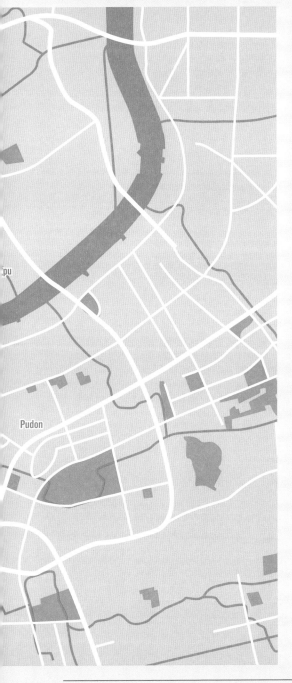

pu

Pudon

33.
THE POSTMODERN LIFE OF MY AUNT (2007)
Jiajun Tavern, Zhapu Road,
Hongkou District
page 92

34.
I WISH I KNEW (2010)
World Expo Pavillions, 1099 Guozhan Road,
Pudong New Area
page 94

35.
LADY BLUE SHANGHAI (2010)
Broadway Mansions Hotel, 20 North
Suzhou Road, Hongkou District
page 96

36.
LIKE A DREAM (2010)
Footbridge over Xizang Middle Road and
East Yan An Road, Huangpu District
page 98

37.
MAN ZOU: BEIJING TO SHANGHAI (2010)
Lujiazui District, Pudong New Area
page 100

38.
NO.89 SHIMEN ROAD (2010)
Huayi Road, Huangpu District
page 102

39.
SHANGHAI (2010)
The Glen Line Building, 28 The Bund
page 104

THE POSTMODERN LIFE OF MY AUNT/
YIMA DE HOUXIANDAI SHENGHUO (2007)

LOCATION *Zhapu Road, Hongkou District*

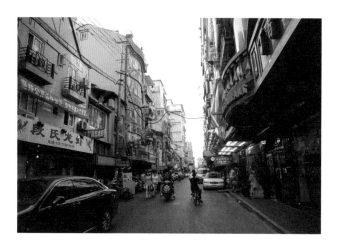

'AUNTIE'' YE RUTANG (Siqin Gaowa) is a woman past her prime and very much a loner in Shanghai. As an intellectual, she has led a simple life for many years, but one that exemplifies the virtues of abiding the laws of society and furthering its betterment. One day, through a chance encounter, she meets the elegant and charming Pan Zhichang (Chow Yun Fat). Her peaceful life now takes a new turn. Pan and Auntie's first date occurs in a restaurant on Zhapu Road where Auntie is mesmerized by Pan's literary competence. The camera pans around the outside of the restaurant to reveal different styles of architecture on both sides of Zhapu Road. We see attractive historical buildings of classical colonial design with much of their facades covered by neon-lit signboards and light boxes, as if to lead us to think of the aroused ripples in Auntie's heart. The sight of these old buildings gives the street a unique air of culture, reminding onlookers of the classic style of a bygone era. Behind the scene, however, a very different reality reveals them to be venues for decadent contemporary pleasure activities, mirroring the character of Pan, whose outward gracefulness and gentlemanly appearance conceals the fact that he is really a man of deceit. Auntie's innocence in her kindness and fondness towards the undeserved Pan reflects her ignorance of Shanghai, a city fused with new and old, good and bad, a complex space which gradually leads her life into an irreversible downward spiral. **⇢Chu Kiu-wai**

Directed by Ann Hui
Scene description: First Date
Timecode for scene: 0:34:27 – 0:37:21

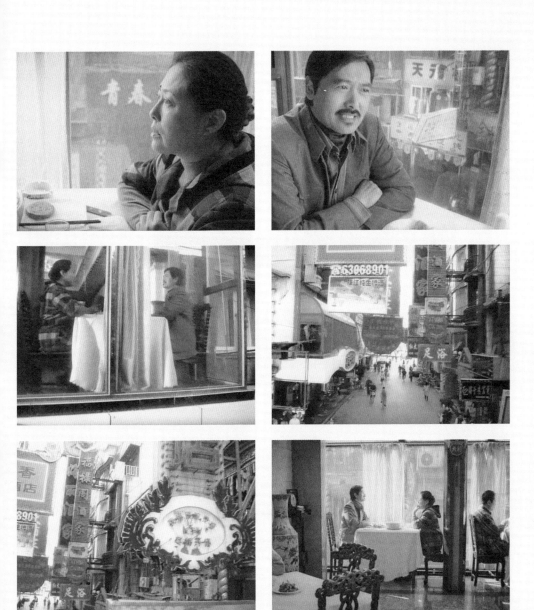

I WISH I KNEW/HAI SHANG CHUAN QI (2010)

LOCATION

The construction site of World Expo Park,
1099 Guozhan Road Pudong New Area

I WISH I KNEW is an elaborate documentary that focuses on subjects who have been witness to Shanghai's changes over the past several decades. While the Shanghai World Expo site is under construction, actress Zhao Tao ushers people into a vast space with assorted shapes of architecture, soon to be examined by visitors from all over the world. The site is dotted with migrant workers whose blood, toil and sweat will make this expo possible. Nicknamed the Oriental Crown due to its resemblance to an ancient Chinese crown, the red China pavilion under construction is detectable amongst brick and stone. It symbolizes a unity of heaven and earth. The camera then moves into the canteen, where workers are queuing for a meal, while a banner on the wall reads, 'Present a great world expo to glorify the nation.' The age of the workers varies, although most of them are men. Upbeat music introduces a young peasant dancing in front of huge piles of building materials. His cool movements defy the surrounding darkness and the relentless work that he has undertaken throughout the day. The Shanghai World Expo ultimately broke records in terms of the number of participants, the size of the site, and its budget. It was this project that brought new subway lines to Shanghai and displaced over 10,000 local families. The pavilion has now been converted into the China Art Museum, with a visual art exhibition as its main programme. Shanghai is no longer what it used to be. ➡**Xu Jia**

Directed by Jia Zhangke
Scene description: Shanghai prepares to welcome the world
Timecode for scene: 1:42:12 – 1:44:13

LADY BLUE SHANGHAI (2010)

Broadway Mansions Hotel, 20 North Suzhou Road, Hongkou District

BUILT IN 1934, the nineteen-floor Broadway Mansions Hotel is a five-star establishment that was designed by the British architect Bright Fraser. Yet it becomes a space of unease in *Lady Blue Shanghai*, a short film by David Lynch that was commissioned by the French fashion house Christian Dior as part of a web series to promote the latest incarnation of its classic Lady Blue handbag. Marion (Marion Cotillard), who is in Shanghai on business, enters the hotel and passes through its lobby, taking the elevator to her room. As she walks down the corridor, she hears the 1927 recording of 'Fate' ('Tango Valentino') by Nathaniel Shilkret. Realizing that the music is coming from her room, she enters and finds the record playing on a vintage phonograph. Stopping it results in a blinding light, then a puff of smoke, from which a Lady Dior bag appears. Disturbed by this strange occurrence, Marion calls down to the front desk, and the clerk arranges for two members of the hotel security staff to investigate. She then stares at the expensive item, which holds an emotional significance that is buried in her subconscious. The marketing strategy of Dior converges with Lynch's recurrent themes in *Lady Blue Shanghai*, as the city is positioned as a place of luxury culture while provoking anxiety related to repressed memory. Consequently, the affluent trappings of the Broadway Mansions Hotel take on a sinister dimension, with the steadily ominous camera-work being accompanied by an unsettling soundscape of low-frequency drones. ⁓*John Berra*

Photo © Jiahui Xu

Directed by David Lynch
Scene description: Luxury Nightmare
Timecode for scene: 0:00:18 – 0:03:52

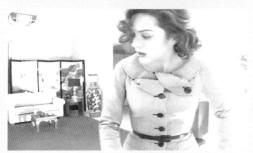

LIKE A DREAM/RU MENG (2010)

LOCATION *Footbridge over East Yan An Road*
& Xizang Middle Road, Huangpu District

IN THIS ROMANTIC DRAMA, American-born Chinese Max (Daniel Wu) meets a mysterious girl in his dream. She is constantly on his mind, upsetting his daily routine to such an extent that he gradually detaches from reality. On one of his trips to Shanghai, Max accidentally finds photographs of his dream girl and, later in Hangzhou, meets country girl Yiyi (Yolanda Yuan) who looks identical, but has a very different temperament. Yiyi accompanies Max to Shanghai in search of the girl and the beautiful but illusory environment that Max encountered in his dream. Together they trace the trail of the girl to all the popular landmarks. They come upon a pedestrian bridge where the girl has taken photos with distant Pudong skyscrapers on the other side of the Bund as a backdrop. Despite her melancholic look, images of the dream girl captured with the Broadway Mansions Hotel, the Oriental Pearl Tower and other city settings as backgrounds, richly project her cosmopolitan attire and cultivated sophistication. Yiyi finds herself to be incompatible in attempts to imitate the dream girl, and other Shanghai women, in terms of her expressions or manners of movement. To the two strangers, prosperous Shanghai appears even more unfamiliar and dazed than in a dream world. As a transnational co-production, *Like a Dream* features scenic postcard representations of Shanghai with out-of-focus backgrounds that reflect multinational film-making viewpoints. Everywhere in the film, Shanghai and its people are presented as dream-like beings that are disorientated and mysterious, rendering them incomprehensible to outsiders. **➻Chu Kiu-wai**

Photo © Jiahui Xu

Directed by Clara Law
Scene description: *Two outsiders search for a mysterious dream girl*
Timecode for scene: *0:42:23 – 0:43:45*

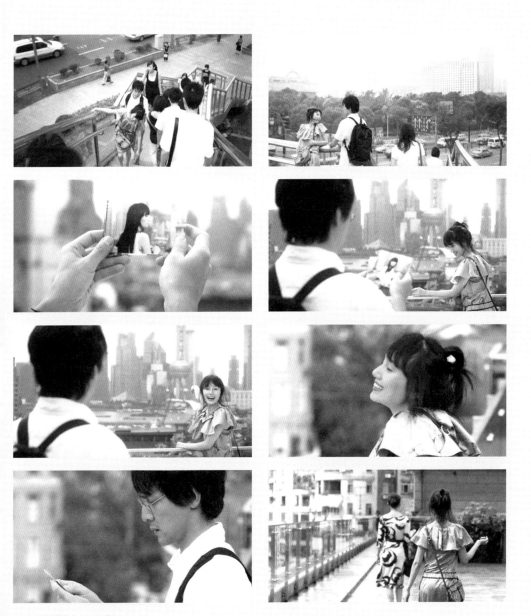

MAN ZOU: BEIJING TO SHANGHAI (2010)

Lujiazui District, Pudong New Area

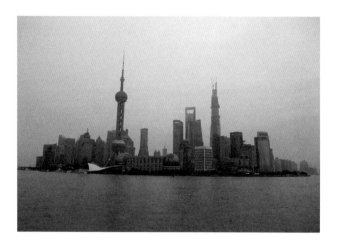

JASON REID'S DOCUMENTARY focuses on four American cyclists who have undertaken a long journey through China's countryside in the weeks following the 2008 Olympic Games. After one month of intensive peddling, they finally arrive in Shanghai. Each of the cyclists talks about the big contrast between the rural areas that they have seen on the way and this megacity that never seems to sleep. Skyscrapers, neon lights, international banks, Nanjing Road, busy traffic and the bustling crowds are mere slices of the whole spectrum offered by this metropolis, a place that allows few people to 'man zhou' (walk slowly). One cyclist states that Shanghai does not actually feel like China as it is so modern and westernized. It is a cliché to say this is a city that combines East and West, but the seamless co-existence of a global financial centre with traditional *shikumen* lifestyle is tangible evidence of its capacity for and attachment to heritage. However, constantly boosting Shanghai's economic development poses a threat to its already vulnerable environment. Smog, contaminated water and decreased biodiversity are only some of the local problems. If these cyclists were to revisit Shanghai ten years after the making of this documentary, they might find it difficult to recognize the areas with which they became acquainted. Lots of buildings have since been repaired or demolished and rebuilt. New structures serve to refresh the city's skyline as the Shanghai of the twenty-first century aims not merely to survive but to thrive. **◆◆Xu Jia**

Photo © Jiahui Xu

Directed by Jason Reid
Scene description: Four cyclists consider Shanghai's new urban spaces
Timecode for scene: 1:15:47 – 1:18:05

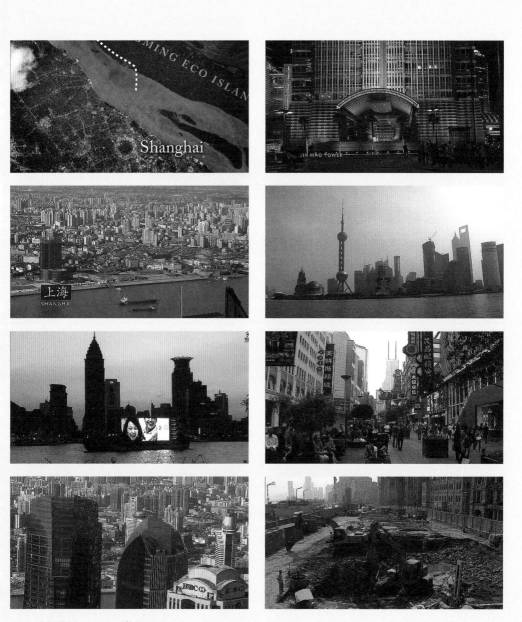

Images © 2010 2R Productions/8 Rivers Films

NO. 89 SHIMEN ROAD/HEI BAI ZHAO PIAN (2010)

LOCATION *Recreation of Shimen Yi Road,
Jing'an District at Huayi Street, Huangpu District*

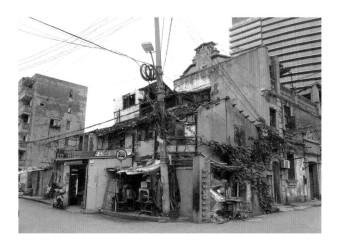

HAOLUN SHU OPENS his film with a slideshow of black-and-white photographs which capture his soon-to-be-demolished old home in the neighbourhood of Dazhongli in the late 1980s. What follows is the reconstruction of Dazhongli, which was still not completely urbanized to the extent that there was no trace of Old Town innocence. Shu narrates his story through the eyes of Xiaoli, a teenager who has made a hobby of taking snapshots of his neighbourhood. Xiaoli resides in one of the *shikumen* houses that were typical of the era. Along the *longtang*, as seen through his window, youthful and elderly residents of the neighbourhood spend their time playing cards or table tennis, indulging in a variety of community activities or simply chatting with each other in small groups. These alleys are seen to be fronted on both sides by traditional red-brick-walled terraced housing. Above the multitude of activities, the household washings hangs on drying lines, adding a range of colours to the sky, while in a communal kitchen, residents from different households are seen preparing their daily meals, giving this old residential neighbourhood an air of vitality and harmony. Due to extensive urban development in the early 1990s, the original Dazhongli neighbourhood has now been replaced by shiny skyscrapers. Residents were compelled to move from the area, putting an end to the happy and intimate community life seen here. All over the city, the rapidly disappearance of old *longtang* neighbourhoods causes one to feel intensely nostalgic. ⇢ *Chu Kiu-wai*

Photo © Jiahui Xu

Directed by Haolun Shu
Scene description: Nostalgic neighbourhood memories
Timecode for scene: 0:00:45 – 0:03:58

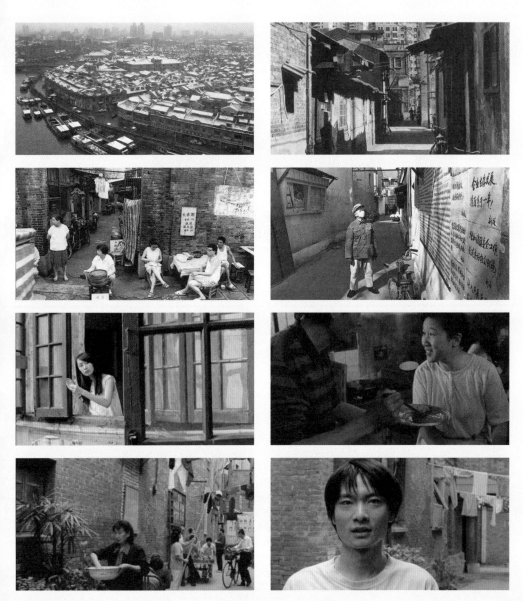

Images © 2010 IDTV Film

SHANGHAI (2010)

LOCATION *Soundstage recreation of the German Consulate, Glen Line Building, 28 The Bund*

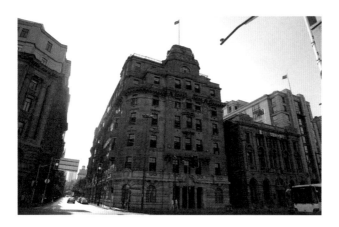

IN THIS OLD-FASHIONED wartime thriller, American journalist Paul Soames (John Cusack) arrives in Shanghai to work at the *North China Herald* where his reputation as a Nazi-sympathizer angers his editor but ensures that he receives an invitation to a party at the German Consulate. However, it is soon revealed that Soames is actually an undercover agent from the Naval Intelligence Office who is investigating the recent murder of a friend and fellow operative. At the party, Soames meets many of the main players in the convoluted mystery that will unfold against the backdrop of impending conflict: German spy Leni Mueller (Franka Potente), Japanese intelligence chief Captain Tanaka (Ken Watanabe), local mobster Anthony Lan-Ting (Chow Yun-fat) and his alluring wife Anna (Gong Li), who has connections to the Chinese resistance movement. Designed in a Renaissance style by Tug Wilson of the international architecture firm Palmer and Turner, the Glen Line Building is named after the shipping company that initially occupied the premises before it became home to the German consulate during World War II, then the American Consulate in 1945, less than a month after Japan's surrender. For the production of *Shanghai*, the building had to be replicated on a set in Bangkok, Thailand when the permits that the Weinstein Company had secured to shoot on location were revoked by the Chinese government one week prior to the intended start date due to the political sensitivity of the film's time period. Today, the Glen Line Building houses the Shanghai Broadcasting Board. ⇢*John Berra*

Photo © Jiahui Xu

Directed by Mikael Håfström
Scene description: Meeting the main players at the German Consulate
Timecode for scene: 0:17:30 – 0:22:30

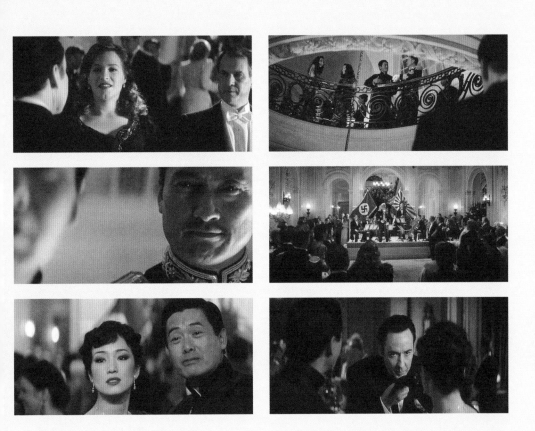

THE GREAT DIVIDE

Depths and Peaks of Shanghai Life

Text by
MARIAGRAZIA
COSTANTINO

IN A CITY LIKE SHANGHAI, extreme wealth meets the intrinsic laws of basic survival. Indeed, a distinctive aspect of Shanghai cinema is this simultaneous presence of extreme polarities: the most extravagant and wild richness can be found side by side with the utmost poverty. It could be argued that such a characteristic is shared by all global megalopolises, but Shanghai is almost defined by this economic divide. As such, inequality has been exalted and stigmatized in Shanghai cinema from its early decades to the present. This aspect has alternatively been seen as a blessing and a curse, something to reproof severely and even censor, especially during the socialist-reformist movement of the late 1920s and 1930s.

The early Shanghai film that best epitomizes the separation between rich and poor is *Malu tianshi/ Street Angel* (Yuan Muzhi, 1937), where this coexistence is allegorically represented by physical 'depths' (the slums of the city) and 'peaks' (clock towers, pinnacles, birds flying overhead, and the art deco design of the Broadway Mansions Hotel).

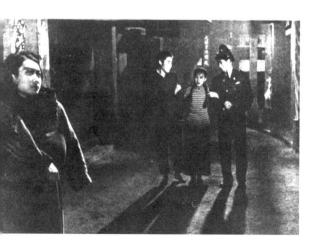

The story follows sisters Xiao Hong (Zhou Xuan) and Xiao Yun (Zhao Huishen) as they struggle to keep up with the city's pace while avoiding being swallowed by poverty. This form of socially engaged cinema arose in Shanghai to condemn the pressure exerted on people by looming modernity and its ruthless rules, but also to oppose paradigmatic stories to the condition of anonymity in which people find themselves.

There is something inherently fascinating about such lifestyle depiction, as evidenced by the attraction–repulsion relationship seen in certain films of the Maoist era. Amongst these is *Wutai jiemei/ Two Stage Sisters* (Xie Jin, 1964) in which the glamorous urban lifestyle is adopted by Xing Yuehong (Cao Yindi), the weakest of the titular sisters, who is morally corrupted. This lifestyle is manifestly stigmatized and juxtaposed with the innocence of the countryside, in this case artificially represented as a timeless paradise. Shanghai is the place where citizens and spectators, despite the different epoch and moral milieu, still demonstrate a voyeuristic fascination for the city lights and their endless promises. *Two Stage Sisters* depicts the streets of Nanjing Road as the cradle of sin, but they also represent an irresistible attraction.

Today, the city of Shanghai is under a constant renovation that does not allow the 'new' to 'grow old'. By the same token, the city is considered by many to be without culture, as traces of the past have been erased by real estate speculation and construction. But Shanghai is also a city marked by the attraction for a fashionable and clearly westernized lifestyle, which is the controversial fate of many postcolonial Asian commercial hubs. Shanghai has to keep up with its problematic fame, and is indeed still characterized by glamour, or at least by a confused and almost naïve idea of what is fashionable.

Yet anyone who has spent more than a week in this city can see that there are huge inequalities in the levels of lifestyle standards. If we look closely at what has happened in the last 70 years, from the Japanese invasion to the constitution of the People's Republic, we can see that Shanghai has been inhabited by the countryside in several forms. As a city devoted to commerce, it has always attracted people from the surrounding rural areas, as illustrated by the introduction and ending of *Dushi fenguang/Scenes of City Life* (Yuan Muzhi, 1935). Today, as a place with countless construction sites, it actually requires manpower from outside, so the inhabitants of high-rise apartments and exclusive residential compounds live side-by-side with the people who build these places. This clash of social classes has come to constitute the so-called 'Shanghai myth', which is proposed or reiterated in almost every narration about the city, either literary or filmic.

The commercial romance *101 ci qui hun/Say Yes!* (Leste Chen, 2013) exposes these contradictions and the difficulty of recomposing them, yet it ultimately dismisses the problem. The split screen of the opening titles effectively introduces the subject matter: the love story between Huang Da (Huang Bo) and Yeh Xun (Lin Chi-ling). They belong to different social classes, have very different careers and live in very different environments. Huang Da is a simple man with his own construction company, while Yeh Xun

Today, the city of Shanghai is under a constant renovation that does not allow the 'new' to 'grow old'.

is a beautiful and successful cello player. While he uses the saw, she gracefully handles the bow of her cello; one eats cheap Shanghai noodles, the other expensive Italian fettuccine. Their lives cross in front of the shark tanks of M1nt, a posh Shanghai club located near the Bund. The subtext throughout *Say Yes!* is that the two worlds represented by these characters are, in the end, not so incompatible, but it seems to be little more than a pretext to show glamorous aspects of Shanghai's lifestyle: fancy restaurants with massive wine reserves; hotels on top of skyscrapers; big villas with top quality furniture; and true love blessed by wealth. Apart from the shot of the Lujiazui skyline, complete with the famous Oriental Pearl Tower, we hardly recognize the real city as the one portrayed in the film.

Xiao Shidai/Tiny Times 1.0 (Guo Jingming, 2013) seems to represent the imperative keywords of Shanghai's lifestyle: success and westernization. The story is of four girls who try to make it in the big city, which is unrealistically portrayed as shiny and brand new. The opening scenes again present the Lujiazui's skyline and various landmark monuments, such as the Shanghai Exhibition Centre. Success seems at one's hand in Shanghai: you want something, you take it. The same is true of money. Three of the girls come from a poor-to-modest background, only one is extremely rich and lives in a fancy apartment full of designer facilities and a huge closet. In the film, such material difference does not affect the friendship, but in reality the huge gap between Shanghai's social levels reveals a sharp classism.

Behind the luxurious splendour of these more recent films, reality is ready to bite. ✢

maps are only to be taken as approximates

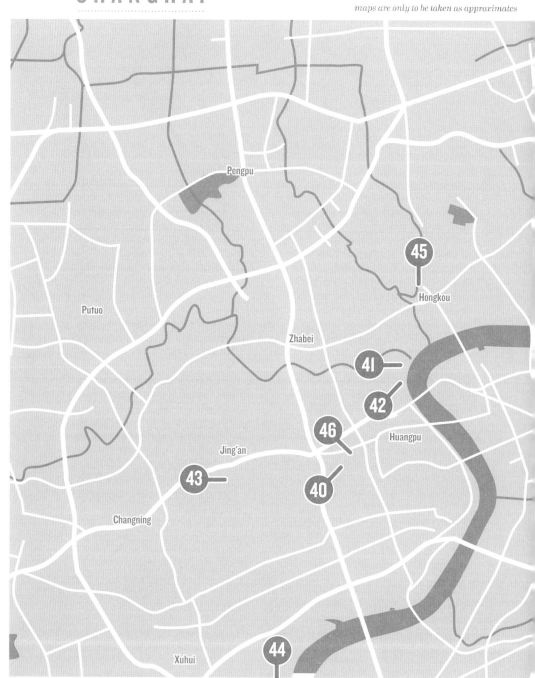

Pengpu

45

Hongkou

Putuo

Zhabei

41

42

46

Huangpu

Jing'an

43

40

Changning

44

Xuhui

SHANGHAI LOCATIONS
SCENES 40-46

pu

Pudon

40.

BEGINNING OF THE GREAT REVIVAL
(2011)
Museum of the First National Congress of
the Chinese Communist Party, 76 Xingye
Road, Xintiandi, Huangpu District
page 110

41.

SNOW FLOWER AND THE SECRET FAN
(2011)
The Peninsula, 32 Zhongshan East 1st Road,
Huangpu District
page 112

42.

LOOPER (2012)
The Bund, Shanghai Film Park, 4915, Bei
Song Highway, Chedun, Songjiang District
page 114

43.

SHANGHAI CALLING (2012)
Southern Belle, 433 Chang Le Road,
Xuhui District
page 116

44.

SKYFALL (2012)
Shanghai Pudong International Airport,
Shanghai expressway
page 118

45.

SAY YES! (2013)
1933 Shanghai, 611 Li Yang Road,
Hongkou Distrct
page 120

46.

TINY TIMES 1.0 (2013)
Muse 2, 4th Floor, Hong Kong Plaza, 283
Huaihai Zhong Road, Huangpu District
page 122

BEGINNING OF THE GREAT REVIVAL/ JIAN DANG WEI YE (2011)

LOCATION *Museum of the First National Congress of the Chinese Communist Party, 76 Xingye Road, Xintiandi, Huangpu District*

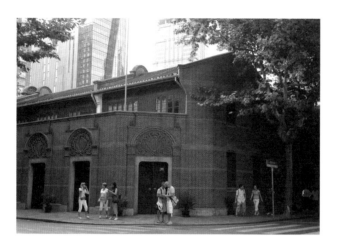

BEGINNING OF THE GREAT REVIVAL is a state-sponsored production released in 2011 to celebrate the 90th anniversary of the founding of the Communist Party of China (CPC) in 1921. The film depicts the historical emergence of the CPC, from the fall of the Qing Dynasty in 1911, through the May Fourth Movement in 1919, to the founding of the party in Shanghai in 1921. It is a companion to the similar historical epic *Jian guo da ye/The Founding of a Republic* (Han Sanping and Huang Jianxin, 2009), which was produced to commemorate the 60th anniversary of the founding of the People's Republic of China. The film features more than 150 famous Chinese actors including Andy Lau, Jackie Chan and Chow Yun-fat, who reportedly appeared without payment. It was produced by the China Film Group Corporation, the country's largest state-owned film corporation, and the film's domestic gross reached 410 million Yuan, placing *Beginning of the Great Revival* as the year's fifth most popular box office attraction. It was reported, however, that this commercial success was due to the film's reliance on state support, including the blackout of potential competitors during its initial weeks, as well as mass viewing through free tickets distribution. The scene featured here is the historical recounting of the beginning of the CPC in July 1921 during the First National Congress of the CPC. This took place at the address formerly known as 106 Wangzhi Road, now part of Xintiandi and now one of Shanghai's most upscale areas. **•Seio Nakajima**

Photo © Jiahui Xu

Directed by Han Sanping and Huang Jianxin
Scene description: The First National Congress of the Communist Party of China
Timecode for scene: 1:42:56 – 1:44:03

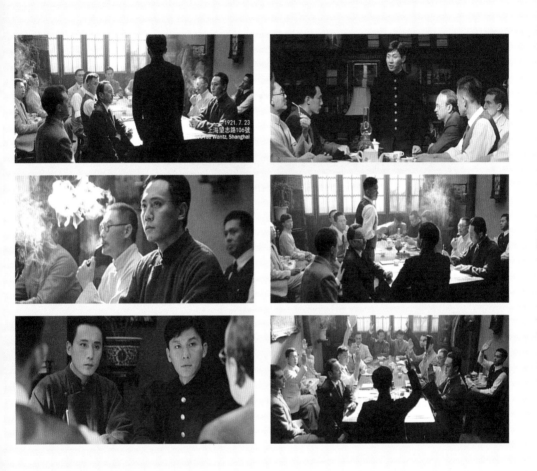

SNOW FLOWER AND THE SECRET FAN (2011)

The Peninsula, 32 Zhongshan East 1st Road, Huangpu District

WAYNE WANG'S TASTEFUL adaptation of the 2007 novel *Snow Flower and the Secret Fan* by Lisa See is a multi-layered chronicle of two nineteenth-century Chinese girls who enter into a *laotong* (lifelong friendship), and their present-day descendants who develop a similar relationship based on a shared teenage love of Canto-pop singer Faye Wong's iconic album *Fu Zao* ('Restless'). In the contemporary strand, the friendship between Nina (Li Bingbin) and Sophia (Gianna Jun) has faltered in adulthood, with the two women largely going their separate ways while living in Shanghai. It is during this period of estrangement that Nina meets Arthur (Hugh Jackman), a charming Australian lounge singer, who performs his act at the Peninsula. This luxury hotel was opened in 2010 and was designed to recreate the opulence of the 1920s, when Shanghai was at its peak of activity as a merchant port. The hotel is the ideal choice for wealthy travellers who wish to revel in the city's revitalized image as the 'Paris of the East', while also providing after-hours escapism for upwardly-mobile inhabitants. Arthur's entertainment strategy is a combination of old-school numbers and flirtatious audience participation, as he roams the room while performing in order to directly engage with the spectators, who are clearly besotted by his charisma. Nina is captivated by Arthur's confident presence, but subsequent events will make her realize that true friendship transcends not only the attentions of this playboy singer, but all the luxurious surroundings that Shanghai has to offer. **•❖ John Berra**

Photo © Jiahui Xu

Directed by Wayne Wang
Scene description: Old-school showman Arthur works the room at The Peninsula
Timecode for scene: 1:10:00 – 1:11:23

Images © 2011 Fox Searchlight Pictures

LOOPER (2012)

The Bund, Shanghai Film Park, 4915, Bei Song Highway, Chedun, Songjiang District

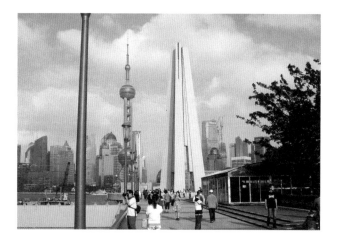

TWENTY-FIVE YEARS in Shanghai rushes by in less than two minutes of screen-time in Ryan Johnston's science fiction thriller *Looper*. Joe (Joseph Gordon-Levitt) relocates to the city in 2044 after taking early retirement from his career as a professional killer for a Kansas City crime syndicate. Taking residence in a stylish high-rise apartment, Joe enjoys the touristic spectacle of the Bund and plays games with the local children in the preserved backstreets. Within three years, however, he has fallen into a spiral of drug addiction which forces him to return to a life of crime in order to fund his habit, taking down a series of scores in ruthless fashion. By the twenty-third year, Gordon-Levitt has aged into Bruce Willis, while the older Joe spends his evenings getting involved in bar brawls until he notices a beautiful woman (Xu Qing) who offers a chance of redemption. She initially rebuffs his advances, but two years later, is happily married to the cleaned-up Joe. Shanghai in *Looper* is positioned as a city of the future, which promises a new life to Joe, yet also harbours a dangerous underworld that soon pulls the former assassin back into a life of violence. The mainland China theatrical cut of *Looper* features an alternative version of this sequence with additional footage of both old and young Joe wandering around the Bund, as extra Shanghai material was requested by Chinese production partner DMG Entertainment, although Joe's drug use was minimized to adhere to local censorship guidelines. ➥ *John Berra*

Photo © John Berra

Directed by Ryan Johnston
Scene description: Twenty-five years in Shanghai
Timecode for scene: 0:31:58 – 0:33:42

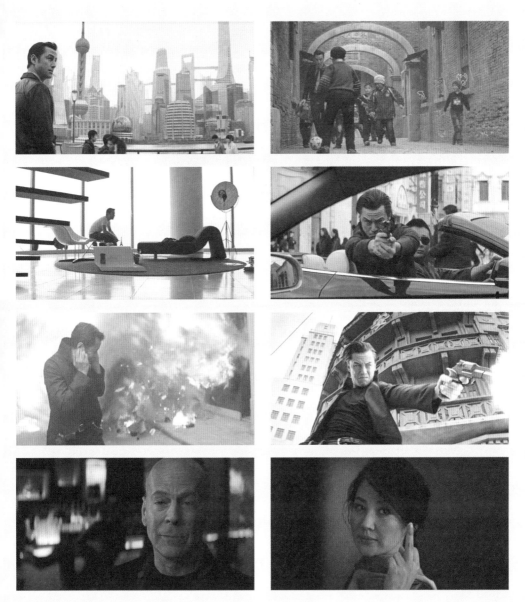

Images © 2012 DMG Entertainment/Endgame Entertainment

SHANGHAI CALLING (2012)

LOCATION *Southern Belle, 433 Chang Le Road, Xuhui District*

SHANGHAI MAY OFFER some of the world's most wonderful restaurants, but its considerable ex-pat community often yearns for more familiar eating or drinking experiences, at which point they head for bars like the Southern Belle, here doubling for a branch of the American chain Red White & Brew. The proprietor of this establishment is Donald Cafferty (Bill Paxton), an 'old China hand' who provides advice to businessmen that are new to the city while maintaining his presidency of the Shanghai branch of the American Chamber of Commerce. The walls of Donald's bar are adorned with photographs of him with various high-profile visitors, such as politically contentious former US President George W. Bush, although Esther Woo (Kara Wang), who intends to run against Donald for AmCham leadership, is more impressed by a shot of the owner with billionaire investor Warren Buffet. The ambitious Esther informs Donald that, 'Shanghai isn't a hardship post for outcasts anymore', on the basis that it is now home to many highly qualified young professionals like herself, but Donald is in his element and not particularly worried by her challenge. He then turns his attention to recently transplanted New York lawyer Sam Chao (Daniel Henney) who is having problems closing a deal to manufacture a new cellphone and recommends a local problem solver known as 'Awesome Wang'. Sam may dismiss the name of the suggested contact as 'ridiculous', but the confidence that Donald exudes from behind the bar will prompt him to make the call. **↝ John Berra**

Photo © Jiahui Xu

Directed by Daniel Hsia
Scene description: Business advice at the Red White & Brew
Timecode for scene: 0:25:53 – 0:28:08

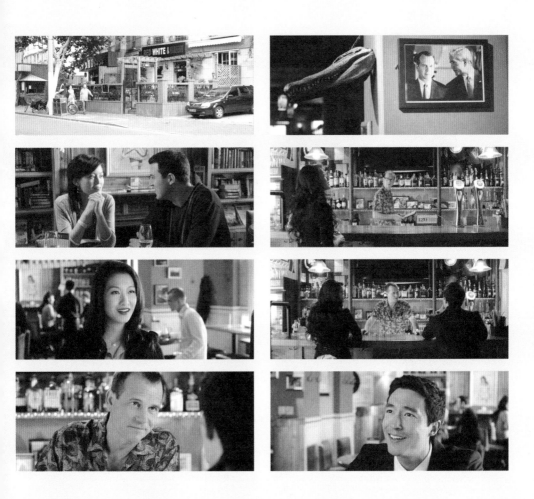

SKYFALL (2012)

Shanghai Pudong International Airport, Shanghai expressway

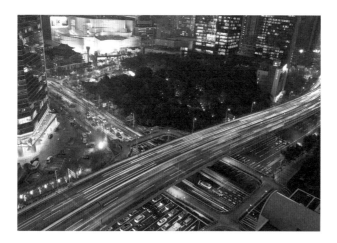

MAINLAND CHINA served as a largely unseen plot element in the James Bond adventure *Tomorrow Never Dies* (Roger Spottiswoode, 1997), in which Special Agent 007 (Pierce Brosnan) was pitted against a villainous media baron who intended to provoke a war between Britain and China by firing a stolen cruise missile stolen at Beijing. Fifteen years and a divisive casting change later, China becomes a fully-fledged location player in *Skyfall*, with Bond (now played by Daniel Craig) travelling to Shanghai to find out who is responsible for the theft of a computer hard drive containing highly sensitive case files. Bond identifies an assassin with whom he has previously tangled at Pudong International Airport, and then tails his quarry around the brightly lit expressway that connects to the commercial centre. It's a futuristic landscape that illustrates points later made by M (Judi Dench) regarding a new era of terror, where threats can go undetected beneath the deceptively smooth surface of globalization. The use of Shanghai as a location in *Skyfall* shows the gradual openness of mainland China to foreign productions, while acknowledging the fact that the People's Republic is now the second-biggest box office market in the world after the United States. In the context of the 007 series, however, Bond's surveillance of a dangerous threat to his beloved country via late-night navigation of the expressway is entirely in-keeping with its signature blend of coolly-stylish modernity, classic spy tropes and the exotic connotations of a major East Asian city. ➻ *John Berra*

Directed by Sam Mendes
Scene description: Surveillance in Shanghai
Timecode for scene: 0:42:58 – 0:44:25

SAY YES!/101 CI QUI HUN (2013)

1933 Shanghai, 611 Li Yang Road, Hongkou District

ADAPTED FROM THE HUGELY POPULAR Japanese television series *101st Marriage Proposal* (Fuji TV, 1991), the romantic-comedy *Say Yes!* focuses on the unlikely love story that unfolds between straightforward construction worker Huang Da (Huang Bo) and glamorous cellist Yeh Shun (Lin Chiling), who was left at the altar three years earlier. One of the main locations in *Say Yes!* is 1933 Shanghai, an eerie Gotham-deco building. Built in 1933 by Chinese developers, the four-story concrete slaughterhouse was designed by British architects and was once the largest abattoir in Asia. During wartime, the massive building survived repeated bombings, and has since served a number of purposes, such as medicine factory and cold storage facility. After years of abandonment, the structure underwent major renovation and reconstruction in 1998. Its current incarnation represents a combination of western design touches, eastern ideologies and religious elements. Today, 1933 Shanghai has been transformed into a creative hub which houses art shops, cafes, design companies, fashion boutiques, galleries and restaurants, while there is a glass-floored stage on the top level. Various social levels converge at the development in this scene: it is home to Yeh Shun's rehearsal studio and the bridal dress shop run by her friend Taozi (Qin Hailu), while Huang Da shows up with his crew to collect the money that he is owed by orchestra sponsor Zhao (Wang Xun) for renovating the wealthy businessman's villa. It looks like the contractor will be leaving empty-handed, but Yeh Shun and Taozi intervene to make sure that Zhao settles the debt. ↦ **Wei Ju**

Photo © Jiahui Xu

Directed by Leste Chen
Scene description: Matters of love and money
Timecode for scene: 0:15:41 – 0:22:55

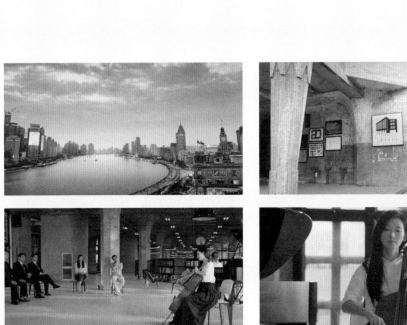

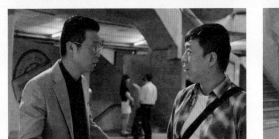

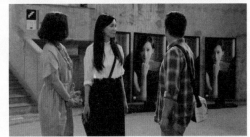

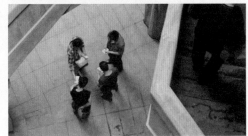

Images © 2013 New Classics Media/Village Roadshow Pictures Asia

TINY TIMES 1.0/XIAO SHIDAI (2013)

LOCATION *Muse 2, 4th Floor, Hong Kong Plaza,*
283 Huaihai Zhong Road, Huangpu District

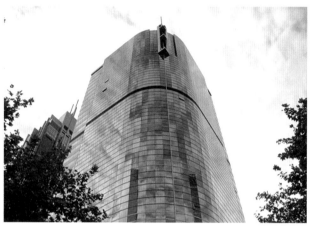

TINY TIMES 1.0 is the first of three films by Guo Jingming that have been adapted from his best-selling 2008 young adult novel of the same name. Although born in Zigong, Sichuan province, Guo relocated to Shanghai for college education and, out of a desire to stay in the city after graduation, turned to chronicling the lives of its youthful inhabitants in the form of literary fiction, subsequently bringing these characters to the screen in a slick commercial package. *Tiny Times 1.0* focuses on four lifelong friends who must tackle the challenges of a transformative Shanghai, keeping up with its latest fashion trends while somehow remaining true to themselves. In tandem with its depiction of the upwardly mobile lifestyles of its central quartet, the film provides a tour of the city's most fashionable social spaces: 1933 Shanghai, Cool Docks and Shanghai International Fashion Centre all feature in this critically reviled but hugely popular romantic drama as matters of the heart are conducted in stylish hang-outs. This scene takes place on the rooftop of Muse 2, the latest incarnation of the club franchise owned by Hong Kong star Carina Lau Kar-ling that was initially located on West Nanjing Road. Magazine staffer Lin Xiao (Yang Mi) attends a chic work-related party where 'the water looks so much like champagne' but must cater to the needs of editor Gong Ming (Rhydian Vaughan). However, she lets her guard down when flirting with charming columnist Zhou Chongguang (Cheney Chen), resulting in an unfortunate poolside stumble. **↝John Berra**

Photo © Jiahui Xu

Directed by Guo Jingming
Scene description: Office Party
Timecode for scene: 0:28:04 – 0:30:00

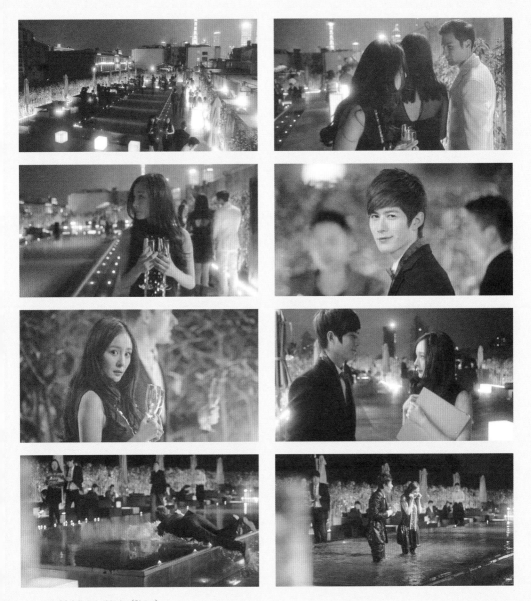

GO FURTHER

Recommended reading, useful websites and film availability

BOOKS

Directory of World Cinema: China
ed. by Gary Bettinson
(Intellect, 2012)

**Beyond Bruce Lee: Chasing the Dragon
through Film, Philosophy, and Popular
Culture**
by Paul Bowman
(Columbia University Press, 2013)

**Tales of Old Shanghai:
The Glorious Past of China's Greatest City**
by Graham Earnshaw
(China Economic Review Publishing, 2012)

Phantom Shanghai
by Greg Girard
(Magenta Foundation, 2010)

**Metro Movies:
Cinematic Urbanism in
Post-Mao China**
by Harry H. Kuoshu
(Southern Illinois University Press, 2010)

Shanghai Right Now
by Kim Laughton
(Outburst, 2010)

The Rough Guide to Shanghai
by Simon Lewis
(Rough Guides, 2011)

Old Shanghai: Gangsters in Paradise
by Lynn Pann
(Marshall Cavendish International Asia,
2011)

**Shanghai: A History in Photographs,
1842–Today**
by Liu Heung Shing and Karen Smith
(Viking, 2011)

**Cities Surround the Countryside: Urban
Aesthetics in Post-Socialist China**
by Robin Visser
(Duke University Press, 2010)

**Shanghai: The Rise and Fall of a
Decadent City 1842-1949**
by Stella Dong
(HarperCollins, 2001)

**Cinema and Urban Culture in Shanghai,
1922–1943**
by Yingjin Zhang
(Stanford University Press, 1999)

**An Amorous History of the Silver Screen:
Shanghai Cinema, 1896–1937**
by Zhen Zhang
(University of Chicago Press, 2006)

Ruan Ling-yu: The Goddess of Shanghai
by Richard Meyer
(Hong Kong University Press, 2005)

ONLINE

The Chinese Film Market
http://www.chinesefilmmarket.com/

Chinese Movie Database
http://www.dianying.com/en/

dGenerate Films
http://www.dgeneratefilms.com

Shanghai Daily
http://www.shanghaidaily.com/

Shanghai Film Museum
http://www.shfilmmuseum.com/

Shanghai Film Park
http://www.shfilmpark.com/

Shanghai International Film Festival
http://www.siff.com/

Shanghaiist
http://shanghaiist.com/

Vantage Shanghai
http://www.vantageshanghai.com/

CONTRIBUTORS

Editor and contributing writer biographies

EDITORS

JOHN BERRA is a lecturer in Film and Language Studies at Tsinghua University. He is the co-editor of *World Film Locations: Beijing* (Intellect, 2012). His articles on Chinese cinema have appeared in *Asian Cinema, Geography Compass* and *Science Fiction Film and Television*. He is also a co-editor of the *East Asian Journal of Popular Culture* and a regular contributor to the industry publication *The Chinese Film Market*. Related activities have included programming retrospectives of contemporary Chinese cinema and subtitling the award-winning independent film *Mei Jie/The Love Songs of Tiedan* (Hao Jie, 2012).

WEI JU is a lecturer in Film and Television Studies at Tongji University. She has also attended Kings College London as a visiting scholar in order to research the British youth cinema. Her research topics have included the influence of piracy on New Chinese Cinema and the typology of Chinese television production. She has contributed to *World Film Locations: Beijing* (Intellect, 2012).

CONTRIBUTORS

MARCELLINE BLOCK (BA, Harvard; PhD cand., Princeton) is the editor of *World Film Locations: Paris* (Intellect, 2011), *World Film Locations: Las Vegas* (Intellect, 2012), *World Film Locations: Prague* (Intellect, 2013), *World Film Locations: Marseilles* (Intellect, 2013), and *Filmer Marseille* (Presses universitaires de Provence, 2013) in addition to *Situating the Feminist Gaze and Spectatorship in Postwar Cinema* (Cambridge Scholars Publishing, 2008; 2nd edn 2010), which was translated into Italian. She is also the co- editor of the *Directory of World Cinema: Belgium* (Intellect, 2014), *Gender Scripts in Medicine and Narrative* (Cambridge Scholars Publishing, 2010); *Unequal before Death* (Cambridge Scholars Publishing, 2012); and Volume 18 of *Critical Matrix: The Princeton Journal of Women, Gender, and Culture*. Her articles and book chapters about film, literature and visual art have appeared in English, Chinese, French, Italian and Russian. She lectured about Paris in Cinema at 92Y TriBeCa, New York City.

MARCO BOHR is a photographer, academic and researcher in visual culture. He has contributed to the *Directory of World Cinema: Japan 2* (Intellect, 2012), *Frontiers of Screen History: Imagining European Borders in Cinema, 1945–2010* (Intellect, 2013) and *On Perfection: An Artists' Symposium* (Intellect, 2013). He has also contributed to the *Dandelion Journal*, the exhibition catalogue for 'Modernity Stripped Bare', held at the University of Maryland in 2011, and the artist book *Kim Jong Il Looking at Things* (Jean Boîte Éditions, 2012).

PAUL BOWMAN is Director of Postgraduate Research Studies at the School of Journalism, Media and Cultural Studies at Cardiff University. He is the author of *Post-Marxism versus Cultural Studies: Theory, Politics and Intervention* (Edinburgh University Press, 2007), *Deconstructing Popular Culture* (Palgrave, 2008), *Theorizing Bruce Lee* (Rodopi, 2010), *Culture and the Media* (Palgrave, 2012), *Reading Rey Chow* (Peter Lang, 2013), and *Beyond Bruce Lee: Chasing the Dragon Through Film, Philosophy, and Popular Culture* (Columbia University Press, 2013) and *The Treasures of Bruce Lee* (Carlton Books, 2013). He is the editor of *Rancière and Film* (Edinburgh University Press, 2013), *The Rey Chow Reader* (Columbia University Press, 2010), *The Truth of Žižek* (Continuum, 2007) and *Reading Rancière* (Continuum, 2011).

HIU M. CHAN is a Ph.D. candidate in Film and Cultural Studies at Cardiff University. Her research ➜

CONTRIBUTORS

Editor and contributing writer biographies (continued)

is a comparison study of Chinese and western film theory. She adores the people, fashion and culture of Old Shanghai and therefore watches a lot of old Chinese films or contemporary period films that are set in that era. She runs the blog *Vintage Chinese*, where she collects old photographs from the 1910s–40s and contemporary film stills with period costumes. She thinks that there is something very special about the mixture of *cheungsam* or *qipao* (traditional Chinese dress) and suits in visual culture, and believes it is one of the most beautiful aesthetics when East meets West.

CHU KIU-WAI is a Ph.D. candidate in Comparative Literature from the University of Hong Kong, and a visiting Fulbright scholar (2012–13) in the University of Idaho. He received his previous degrees from SOAS, University of London and University of Cambridge. His research focuses on contemporary Chinese cinema and art, ecocriticism and environmental thought in visual culture. His publications can be found in *Neverthere: Images of Lost and Othered Children in Contemporary Cinema* (Lexington Books, 2012), *Modern Art Asia: Selected Papers Issue 1–8.* (Enzo Arts and Publishing, 2012), *World Film Locations: Beijing* (Intellect, 2012) and *Transnational Ecocinema* (Intellect, 2013).

MARIAGRAZIA COSTANTINO is a sinologist and specialist in Film and Contemporary Art. She holds a BA in Chinese Studies (University of Rome La Sapienza), an MA degree in Media and Film (SOAS, University of London) and a Ph.D. in Film Studies (Roma Tre University). Her Ph.D. dissertation, which she completed during a programme as a visiting scholar at SOAS, concerns the ideological representation of urban spaces in film from East Asia. From 2000 she has been researching Chinese visual culture, multimedia art and film in Hangzhou and Beijing. She has also

studied Mandarin at the Peking University. She currently lives and works in Shanghai as an art curator and critic.

ZACHARY INGLE is a Ph.D. candidate in Film and Media Studies at the University of Kansas. This is the fifth volume that he has contributed to in the *World Film Locations* series. He has also contributed to the *Fan Phenomena* series and the *Directory of World Cinema* series. He has edited *Robert Rodriguez: Interviews* (University Press of Mississippi, 2012), *Gender and Genre in Sports Documentaries* (Scarecrow Press, 2013) and *Identity and Myth in Sports Documentaries* (Scarecrow Press, 2013). He is currently editing *Fan Phenomena: The Big Lebowski* (Intellect, forthcoming).

BJARKE LIBORIUSSEN is Assistant Professor in Digital and Creative Media at the University of Nottingham Ningbo China. He has a background in film and game studies. His current research is on the use of tools in the creative industries, and is based on interviews with Chinese animators, architects and designers.

MA RAN is a senior lecturer at the Graduate School of Letters, Nagoya University, Japan. She received her MA in Film Studies from the University of Amsterdam in 2005 and her Ph.D. at the Department of Comparative Literature, University of Hong Kong, in 2011. Her doctoral project examines Chinese independent cinema in the context of international film festival networks, while her postdoctoral research (2010–13) extends this subject to explore participatory art projects in Asian cities. Currently, her research project focuses on the grassroots-level, independent film festival network in Japan and South Korea. Her publications include essays, reports and interviews on China's film festivals and Chinese independent cinema.

DAVE MCCAIG is a senior lecturer in Media Theory at the University of Lincoln. He coordinates and teaches on a variety of modules on the BA Media Production, BA Film and Television Studies and the MA Media Theory. His current research interests are based around issues of post-IMF representation within South Korean film adaptations of Gueyoni's Internet novels and the cinema of Lee Chang-dong. He has previously contributed to *World Film Locations: Beijing* (Intellect, 2012) while forthcoming publications include contributions to the *Directory of World Cinema: South Korea* (Intellect, 2013) and the *Routledge Encyclopaedia of World Cinemas* (Routledge, 2014).

SEIO NAKAJIMA teaches Asian studies at Waseda University. He has conducted organizational analyses of the Chinese film industry, as well as ethnographies of Chinese film audiences and consumption. His research has appeared in *From Underground to Independent: Alternative Film Culture in Contemporary China* (Rowman & Littlefield, 2006), *Reclaiming Chinese Society: The New Social Activism* (Routledge, 2009) and *The New Chinese Documentary Film Movement: For the Public Record* (Hong Kong University Press, 2009). He has recently expanded his research interests to sociology of art, and his article 'Prosumption in Art' (2012) has appeared in *American Behavioral Scientist*.

DONNA ONG is a Ph.D. candidate at the University of Hong Kong's Department of Comparative Literature. Her current research is on Liu Na'ou and the 1930s Chinese Soft Film movement, focusing on early film theory and revisionist history of Pre-1949 Chinese films. Prior to her post-graduate studies, Donna undertook her BA in Film Studies and Political Science at Yale University, and her MA in Development Studies at the School of Oriental and African studies, University of London. She has also lived and worked in several places in Asia, two years of which were in Beijing.

WENFEI WANG is an MA candidate at the School of Liberal Arts, Nanjing University. She has worked as a production assistant on the award-winning independent film *Mei Jie/The Love Songs of Tiedan* (Hao Jie, 2012) and contributed to *World Film Locations: Beijing* (Intellect, 2012).

ISABEL WOLTE was awarded a BSc in Computer Science and Artificial Intelligence, and an Msc in Ancient Philosophy at the University of Edinburgh. She is the executive director of her own company, China Film Consult, which specializes in cultural exchange between Europe and China. She completed her Ph.D. on World Literature and Chinese Cinema at the Beijing Film Academy in 2009 and is currently a lecturer at the University of Vienna and the Beijing Film Academy. She has published articles in German on the subject of Chinese cinema. Her research interests include political and social aspects of Chinese cinema, literary adaptations, environmental issues, and intercultural communication. She also contributed to *World Film Locations: Beijing* (Intellect, 2012).

XU JIA studied in the Department of Cinema Studies at Stockholm University, Sweden. She is the editor-in-chief of *The Chinese Film Market* magazine, which is the first and so far only English monthly to report the latest film industry news from Beijing, Taipei and Hong Kong to such global film markets as EFM and Le Marché du Film. She is also an apprentice at the Hope Institute of Chinese Medicine and a regular contributor to *festivalists. com*, a webzine backed by mentors like Dana Linssen and Pamela Biénzobas.

FILMOGRAPHY

All films mentioned or featured in this book

2046 (2004)	51,60,88
Apart Together/Tuan yuan (2010)	68
Armageddon (1998)	89
Beginning of the Great Revival/Jian dang wei ye (2011)	109,110
Center Stage/Ruan Lingyu (1992)	31,36
Code 46 (2003)	51,58,88
Crossroads/Shi zi jie tou (1937)	6,11,22
Daybreak/Tianming (1933)	11,14
Don't Be Young/Wei qing shao nu (1995)	48
Empire of the Sun (1987)	7,31,34
Everlasting Regret/Changhen Ge (2005)	51,66
Fantastic Four: Rise of the Silver Surfer (2007)	89
Fist of Fury/Jing wu men (1972)	7,28,29
Fist of Legend/Jing wu ying xiong (1994)	29
Flowers of Shanghai/Hai shang hua (1998)	31,42
Founding of a Republic, The/Jian guo da ye (2009)	110
Go for Broke/Heng shu heng (2001)	51,52
Goddess,The/Shennu (1934)	5,9,11,16
Godzilla (1954)	62
Godzilla: Final Wars/Gojira: Fainaru wozu (2004)	51,62
Grandmaster, The (2013)	29
House of 72 Tenants, The/Chat sup yee ga fong hak (1973)	64
I wish I Knew/Hai shang chuan qi (2010)	69,91,94
Indiana Jones and the Temple of Doom (1984)	31,32
Ip Man/Yip Man (2008)	29
Ip Man 2/ Yip Man 2: Legend of the Grandmaster (2010)	29
Kung Fu Dunk (2008)	56
Kung Fu Hustle/Gung fu (2004)	51,64
Lady Blue Shanghai (2010)	91,96
Legend of the Fist: The Return of Chen Zhen/ Jing wu feng yun: Chen Zhen (2010)	29
Like a Dream/Ru meng (2010)	91,98
Longest Night in Shanghai, The/Ye Shanghai (2007)	71,84
Looper (2012)	88,89,109,114
Love and Bruises (2011)	49
Love and Duty/Lian ai yu yiwi (1931)	36
Lust, Caution/Se, Jie (2007)	7,71,86
Man Zou: Beijing to Shanghai (2010)	91,100
Metallic Attraction: Kung Fu Cyborg/kei hei hup (2010)	89
Mission: Impossible III (2006)	5,71,76
Mystery/Fucheng mi shi (2012)	49
Nostalgia/Xiang chou (2006)	71,78
Painted Veil, The (2006)	71,80
Perhaps Love/Ruguo Ai (2005)	7,71,72
Postmodern Life of my Aunt, The (2007)	91,92
Purple Butterfly/Zi hudie (2003)	49
Queen of Sports/Tiyu Huanghou (1934)	6,11,18
Red Violin, The/Le Violon rouge (1998)	7,31,44
Rocky (1976)	56
Say Yes/101 ciqui hun (2013)	107,109,120
Scenes of City Life/Dushi fenguang (1935)	11,20,107
Seventh Sin, The (1957)	80
Shanghai (2010)	91,104
Shanghai Baby (2007)	7
Shanghai Calling (2012)	6,109,116
Shanghai Dreams/Qing hong (2005)	7,28
Shanghai Express (1932)	11,12
Shanghai Gesture,The (1941)	6
Shanghai Panic/Wo men hai pa (2001)	7,51,54
Shanghai Story/Meili Shanghai (2006)	7
Shanghai Triad/Yao a yao yao dao waipo qiao (1995)	5,31,38
Shaolin Soccer/Siu lam juk kau (2001)	51,56
Skyfall (2012)	5,7,76,109,118
Snow Flower and the Secret Fan (2011)	5,109,112
Solaris (1972)	88
Song of the Fisherman/Yu guang qu (1934)	5
Spring Fever/Chun feng chen zui de ye wan (2009)	49
Spring in a Small Town/Xiaocheng zhi chun (1948)	9
Spring River Flows East, The/ Yi jiang chun shui xiang dong liu (1947)	6,11,26
Street Angel/Malu tianshi (1937)	5,6,11,20,24,106
Street Life/Nanjing Lu (2006)	7,71,82
Summer Palace/Yihe Yuan (2006)	49
Suzhou River/Suzhou he (2000)	5,7,31,46,49,66
Temptress Moon/Feng yue (1996)	5,31,40
Tiny Times 1.0/Xiao Shidai (2013)	107,109,122
Tomorrow Never Dies (1997)	118
Transformers: Revenge of the Fallen (2009)	89
Two Stage Sisters/Wutai jiemei (1964)	106
Ultraviolet (2006)	88
Weekend Lover/Zhou mo qing ren (1995)	48,49
White Countess,The (2005)	5,71,74
Wild Flowers/Ye cao xian hua (1930)	36